ART IN *focus*

D0017952

Paris

PARIS

Linda Bolton

A Bulfinch Press Book
Little, Brown and Company
Boston • New York • Toronto • London

CONTENTS

KEY

Underground **RER** RER **P** Parking

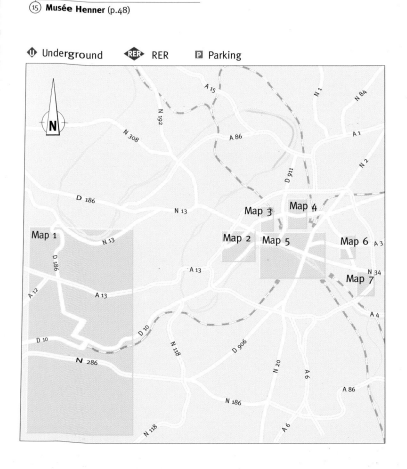

First United States Edition

ISBN 0-8212-2155-8

Library of Congress Catalog Card Number
94-78807

Bulfinch Press is an imprint and trademark
of Little, Brown and Company (Inc.)
Published simultaneously in Canada by
Little, Brown & Company (Canada) Limited

PRINTED IN SINGAPORE

CONTENTS

This guide aims to present the artistic and architectural highlights of Paris so that visitors with a limited amount of time to spend can select what they want to see from a list of carefully chosen museums and galleries, works of art and architecture. No other city in the world contains such a wealth of art in surroundings of such elegance. There are outstanding buildings from every century from the Middle Ages to the present day and the collections themselves are often housed in architectural gems, ranging from the huge and grand Louvre to the exquisite, renovated *hôtels particulières* (private mansions). The richness of Paris's buildings and galleries today reflects the city's long history of pre-eminence in artistic affairs. From the middle of the seventeenth century to the middle of the twentieth century it was unchallenged as the artistic capital of the whole Western world. During this period many of the most important artistic movements were born there and it became a mecca for ambitious young artists from all over Europe and beyond. Since World War Two, New York has taken over as the most exciting centre for avant-garde art, but Paris's sheer weight of tradition still gives it an unrivalled place in the affections of most art lovers. Indeed, it can still lay claim to be the cultural capital of the world, and recently President Mitterand has underlined the city's status with a series of Grands Projets – cultural landmarks on an extremely ambitious scale, intended to live up to the grandest monuments of the past.

The history of Paris dates back to pre-Roman times, when a Gallic settlement grew up around the Ile de la Cité, which was a natural defensive site. The settlement became the Roman city of Lutetia on the left bank, and subsequently the stronghold of the Franks. In 987 Paris became the capital of the kingdom of France and during the next two centuries developed into a major centre of learning and art. The medieval city became particularly renowned for manuscript illuminations and it was in Paris (at the abbey of St Denis) that the Gothic style of architecture was invented. Apart from St Denis, the great medieval buildings of Paris include the famous cathedral of Notre-Dame (1) and the Sainte-Chapelle (page 123), with its glorious stained glass. The Musée de Cluny, housed in a building

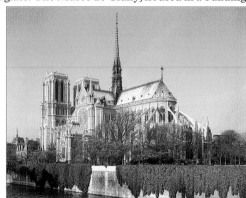

1. NOTRE-DAME CATHEDRAL
FROM THE SOUTHEAST

dating from about 1500, has one of the world's greatest collections of medieval art; its treasures include the *Lady with a Unicorn* series of six tapestries, which capture a romantic view of the Middle Ages (2).

At the end of the fifteenth century the influence of the Italian Renaissance began to be felt in French art. Charles VIII invaded Italy in the 1490s and as a result of his campaigns Italian paintings were brought back to France. His successor Francis I (who reigned from 1515 to 1547) was a great admirer of Italian culture and brought several illustrious

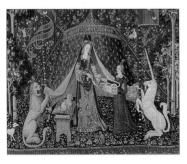

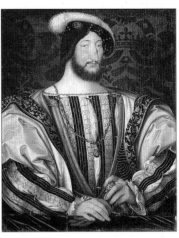

2. (ABOVE) *THE LADY WITH A UNICORN*, 15TH CENTURY (MUSÉE DE CLUNY); 3. (RIGHT) FRANÇOIS (OR JEAN?) CLOUET, *FRANCIS I*, 1530S (LOUVRE)

Italian artists to France (3). The greatest by far was Leonardo da Vinci, who spent his final years at Amboise, where Francis had a château. Leonardo did little artistic work in France, but two of the other artists imported by Francis had a major influence on sixteenth-century French art. They were Francesco Primaticcio and Giovanni Battista Ross (known as Rosso Fiorentino – 'the Florentine redhead'), who in the 1530s together created a distinctive sophisticated Mannerist style at the royal château of Fontainebleau. The term School of Fontainebleau is applied to the work of artists (mainly anonymous) who worked in their style (4). The sculptor and goldsmith Benvenuto Cellini (also famous for his racy autobiography) and the painter Niccolo dell' Abbate (an important figure in the development of landscape painting) were among the other Italian artists to work in France in the mid sixteenth century.

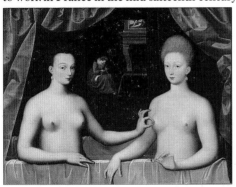

4. SCHOOL OF FONTAINEBLEAU, *GABRIELLE D'ESTRÉES AND HER SISTER, THE DUCHESS OF VILLARS*, LATE 16TH CENTURY (LOUVRE)

In the late sixteenth century France was torn by civil war, and with the court based at Fontainebleau, Paris went through a period of artistic stagnation. However, Henry IV (reigned 1589–1610) was a strong king who not only restored order and prosperity to the country but also began transforming Paris from a medieval town into a great modern capital city. The finest monument of his reign is the Place des Vosges, which is generally regarded as one of the most beautiful squares in the world. Henry's reign ushered in a golden period of French culture and by the end of the seventeenth century France was not only the most powerful nation in Europe

THE GREAT PATRON: LOUIS XIV

The Sun King, who encapsulates the splendour of France and her achievements in the second half of the seventeenth century, is shown here in one of the greatest of all state portraits – an unforgettable image of royal authority. Louis commissioned the portrait to send to his grandson Philip V of Spain, but he was so delighted with it that he kept it in the throne room at Versailles and sent a copy to Madrid. It is easy to see why he loved this image of himself so much, for it perfectly conveys the absolute authority he wielded – a power summed up in his famous remark 'L'Etat c'est moi' (I am the State). No monarch has been more aware than Louis of the value of art as propaganda, and he used it glorify his personality and celebrate the achievements of his reign. The greatest monument of his reign is the palace at Versailles (page 124), which he transformed from a modest hunting lodge into the largest palace in Europe, housing some 20,000 people. Louis also carried out great building works at the Louvre, which at this time was the principal royal residence in Paris (page 50). The most distinguished part of Louis' extensions at the Louvre is the east front, with its great colonnade – one of the supreme masterpieces of French architecture. Originally Louis commissioned the great Italian artist Gianlorenzo Bernini to design the east front, but Bernini's plans were rejected in favour of a design by three French artists, Charles Lebrun, Louis Le Vau and Claude Perrault. Lebrun, who was mainly a painter, was the 'general' who controlled the army of artists and craftsmen who worked on the palaces and other royal projects. Much of their work was produced at the Gobelins tapestry factory in Paris, which Louis took over in 1662 (it had previously been privately owned). It eventually produced not only tapestries, but also virtually every other type of furnishing that the King required.

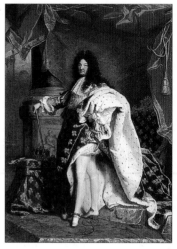

5. HYACINTHE RIGAUD, *Louis XIV*, 1701 (LOUVRE)

but also had taken over from Italy as the acknowledged leader in the arts. An episode of great symbolic importance in this shift of the balance of artistic power came in 1665, when Louis XIV brought Gianlorenzo Bernini, the most famous living artist, from Rome to Paris to work on designs for the east front of the Louvre, then rejected his plans in favour of a French design. In theory Louis had invited Bernini to come, but in reality he command-

6 AND 7. (BELOW) J.B.S. CHARDIN, *GABRIEL GODEFROY WATCHING A TOP SPIN*, C. 1738 (LOUVRE); (RIGHT) FRANÇOIS BOUCHER, *THE DINNER*, 1739, (LOUVRE)

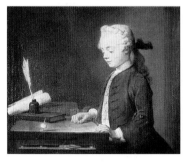

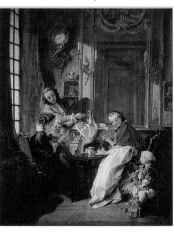

ed him; the Pope (who was humiliated by the incident) had no alternative but to release his great artist to do the French king's bidding.

By a curious irony, the two greatest French painters of this period – Claude and Poussin – spent almost their entire working lives in Rome, but many of their paintings were commissioned by French clients and they had a huge influence on the course of French painting. Poussin in particular set up an ideal of classical purity and dignity that became one of the guiding lights of French art. In architecture a figure of comparable importance was François Mansart – in the eighteenth century, indeed, he was referred to as the 'god of architecture'. His style was noble and grand, but also marked by exquisite precision; in Paris it can best be seen in the church of the Val-de-Grace (although this was not carried out entirely to Mansart's design; he was such a perfectionist that he often disagreed with his patrons

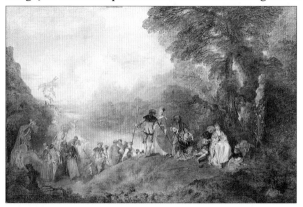

8. JEAN-ANTOINE WATTEAU, *THE PILGRIMAGE TO THE ISLE OF CYTHERA*, 1717 (LOUVRE)

and lost commissions). Mansart's great-nephew, Jules Hardouin-Mansart, was one of the outstanding French architects of the following generation. His style was less refined than that of the great François, but he was a superb organizer – the ideal man to carry out the huge building projects of Louis XIV, notably the palace at Versailles. Similarly in painting, Charles Lebrun, the major artist of Louis XIV's reign, was a much less subtle artist than Poussin, but he was brilliantly successful in marshalling the army of artists and craftsmen who worked on the decoration of Versailles and the other royal buildings. Lebrun himself excelled mainly at huge, multi-figure wall-paintings, but he was also a good portraitist.

<div style="writing-mode: vertical-lr">INTRODUCTION</div>

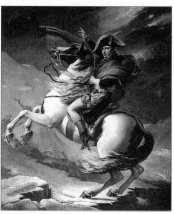

9. J.-L. DAVID, *BONAPARTE AT MONT SAINT BERNARD*, 1801 (VERSAILLES)

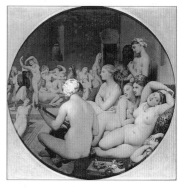

10. J.-A.-D. INGRES, *LE BAIN TURC*, 1863 (LOUVRE)

Around 1700 a reaction began to be felt against the overpoweringly grand style associated with the court of Louis XIV and a lighter, frothier style called Rococo developed. This dominated the first half of the eighteenth century. Three great French painters above all are associated with it: Jean-Antoine Watteau, François Boucher and Jean-Honoré Fragonard (8,7). However, one of the most remarkable painters of the age, Jean-Baptiste-Siméon Chardin (6), trod an independent path, depicting still-lifes and everyday life scenes in a style of dignified simplicity that is far removed from Rococo frivolity. The greatest French architect of the age, Jacques-Ange Gabriel, managed to combine something of the lightness of Rococo with the classical precision of François Mansart. His most spectacular work is the Place de la Concorde, built in the mid eighteenth century. By this time Paris was so dominant in the arts that virtually all ambitious French artists spent at least part of their careers there, and many others came from abroad to see the latest fashions at first hand. Virtually the only way for an artist to make a name in France was by showing his or her work at the Salon, the huge state-sponsored art exhibition that had been established in the eighteenth century (it was held irregularly, but usually annually or every other year).

In the second half of the eighteenth century there was a backlash against the Rococo style, which was challenged by a new style called Neoclassicism. This was influenced by the severe and high-minded art of ancient Greece and Rome In place of the erotic boudoir scenes so beloved

of Rococo painters, Neoclassical artists favoured themes that were morally uplifting, treated in a severe style from which all inessentials had been purged. The leading exponent of this new classicism was Jacques-Louis David, whose most famous paintings are closely associated with the French Revolution. Their subjects, taken from ancient history, are concerned with self-sacrifice and the idea that devotion to the State should come before personal feelings. David was also a superb portraitist, his most memorable sitter being Napoleon, of whom he was a devoted supporter (9). His foremost pupil, Jean-Auguste-Dominique Ingres, continued the Neoclassical tradition into the second half of the nineteenth century but in a highly personal vein (10). France also produced great Neoclassical sculptors and architects, whose work – like that of David and Ingres – is supremely well represented in Paris; Jean-Antoine Houdon was the foremost sculptor of the day, and among architects the most illustrious figures are Germain Soufflot and Claude-Nicolas Ledoux.

HAUSSMANN'S LEGACY

The Paris that we see today is essentially a nineteenth-century city and it owes its appearance mainly to one man – Baron Georges-Eugène Haussmann. A native Parisian and a lawyer by training, this civil servant was one of the most remarkable figures in the history of town planning. He was appointed Prefect of the Seine by Napoleon III and drew up plans to modernize Paris and transform her into the finest city in Europe. Under his organization engineers and architects installed sewers, water pipes and gas mains and laid out parks. Most spectacularly, they demolished the overcrowded twisting streets of the old quarters and replaced them with a series of wide boulevards and avenues, lined with trees and fine buildings. This enormous project, beginning in 1852, took less than two decades to complete and brought Paris into line with the most modern of European cites. The pavements which flanked the newly built streets made leisurely strolling a pleasure and encouraged café life, which is an integral part of the Parisian scene. The cafés opened on to them, offering the clientèle the

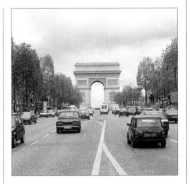

11. THE CHAMPS ELYSÉES LOOKING TOWARDS THE ARC DE TRIOMPHE

pleasure both of being observed and of observing the passing crowds. Haussmann's urban planning was not only effective socially, but also exceedingly impressive visually. He conceived his major thoroughfares as great vistas, leading to such superb focal points as the Arc de Triomphe (11), and this is one of the features that makes Paris still such a beautiful city today. Haussmann's work involved destroying much that was old and interesting, so he has sometimes been seen as a vandal (he was certainly high-handed in his approach). To many more, however, he is one of the city's heroes.

Neoclassical artists had immense respect for the authority of the past; they thought that the Greeks and Romans had set up standards for all time. However, the story of French art in the nineteenth century – particularly French painting – is to some extent a story of progressive revolt against accepted standards and attitudes. The Romantic artists in the early part of the century (Géricault and Delacroix were the greatest) put personal feeling above all else; then Gustave Courbet, the leading exponent of Realism, was bold enough to treat scenes from everyday life with an epic seriousness that had previously been reserved for 'history paintings' – that is, pictures treating lofty themes from religion, mythology or literature. In doing so Courbet challenged the deep-seated idea that there was a clear hierarchy of subjects, with history painting at the top, portraiture and landscape further down, and genre and still life at the bottom. Courbet also challenged the stranglehold of the official Salon, for in 1855 he organized a large exhibition of his own works in Paris.

This attack on officialdom led to subsequent independent shows, including the Salon des Réfusés of 1863, when artists whose work had been rejected by the official Salon put their work on public view at a separate venue. Eleven years later, in 1874, came another milestone – the first group exhibition of the Impressionists. The effect of these shows was to emphasize a separation between mainstream and avant-garde taste, a tendency that has continued to the present day. Many younger painters,

IMPRESSIONISM

Impressionism, the most famous and influential art movement of the 19th century, began in Paris in the 1860s. However, the name was not coined until 1874, when a group of painters whom we now call Impressionists held the first joint exhibition of their work in Paris. One of the paintings shown there, Monet's Impression: Sunrise (now in the Musée Marmottan, page 86), was singled out for sarcastic attack by a journalist and the whole group consequently came to be known as Impressionists. Apart from Monet, the other leading figures of the group included Cézanne, Degas, Manet, Pissarro, Renoir and Sisley. Berthe Morisot (Manet's sister-in-law) was the leading woman artist of the group. These painters were very varied in their aims and outlooks, but at this time they shared an interest in depicting scenes of modern life in a style that tried to capture a sense of the fleeting

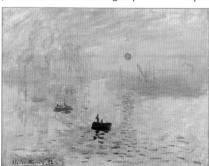

13 AND 14. MONET (LEFT), *IMPRESSION: SUNRISE*, 1872 (MUSÉE MARMOTTAN); (OPPOSITE) *LA RUE MONTORGUEIL*, 1878 (MUSÉE D'ORSAY)

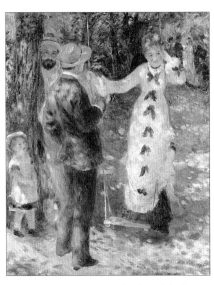

12. RENOIR, THE SWING, 1876
(MUSÉE D'ORSAY)

particularly the Impressionists, felt that art had lost touch with modern life and that they should celebrate the present rather than the past. At the time the Impressionists were at work, Paris was being transformed by Baron

moment. They were interested in the way the light constantly changed and modified the appearance of a subject, and several of them placed particular importance on painting directly from nature out of doors. In this way they aimed to get away from convention and look afresh at the world. The Impressionists held seven more group exhibitions, the last one in 1886. By this time they were developing in different ways and only Monet continued to be true to the ideals of Impressionism for the rest of his life. Although they initially came in for a good deal of mockery, the Impressionists gradually became accepted and their work was enormously influential. Painters everywhere followed their example and began using lighter, brighter colours. Now they are probably the most popular of all groups of painters. Their subject matter is frequently celebratory,

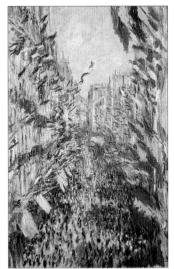

evoking the pleasures of life and especially nature: the joy of a summer stroll through a poppy field, knee-deep in flowers; the beauty of burgeoning leaves in spring; or the sun on blue-white snow in winter.

Haussmann into a modern metropolis and the painters found a wealth of subjects in its streets, parks, cafés and dance halls. The poet and critic Charles Baudelaire summed up the new attitude when he said: 'we in our top hats and patent leather shoes are as heroic as the gods and heroes of Antiquity.' With the new subject matter came a new technique, in which broad sweeping brushstrokes were used to suggest movement and catch the sensation of the fleeting moment.

Impressionism was so influential that much of the history of late nineteenth-century painting can be told in terms of developments from it or reactions against it. The term Post-Impressionist is used to embrace these various tendencies in the period from about 1880 to about 1905 (or up to the outbreak of war in 1914). The four giants of Post-Impressionism were Paul Cézanne, Paul Gauguin, Vincent van Gogh (Dutch-born but working mainly in France) and Georges Seurat. All four thought that Impressionism – in concentrating so much on the appearance of things – had sacrificed deeper meaning, and each of them tried to redress this in different ways. Cézanne brought a new rigour to pictorial structure, endeavouring 'to make of Impressionism something solid and enduring, like the art of the Museums'; Gauguin explored the emotional effects of line and colour and was one of the first artists to be seriously influenced by 'primitive' art; Van Gogh expressed intense inner feelings with an unprecedented force and directness; and Seurat analysed colour in a scientific spirit whilst also bringing to his art a conscious grandeur and formality of composition that was alien to the spirit of Impressionism.

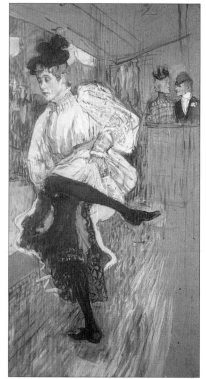

15. HENRI DE TOULOUSE-LAUTREC,
JEANNE AVRIL DANCING, 1892,
(MUSÉE D'ORSAY)

The period when the Post-Impressionists worked is now enshrined in the popular imagination as the classic age of bohemian Paris. This is the world evoked by George du Maurier in his novel *Trilby* (1894) and in a more earthy manner by Toulouse-Lautrec in his paintings and posters of music-halls and theatres, dancers and prostitutes. His curvilinear forms reflect the Art Nouveau style that flourished at the turn of the century, in architecture and the decorative arts especially (some of the older Paris Metro stations have superb metalwork in this style). Slightly later, the run-down charm of Montmartre was beautifully evoked in the street scenes of Maurice Utrillo (whose own bohemian pedigree was perfect; he was the illegitimate son of Suzanne Valadon, a beautiful circus acrobat who became an artists' model and then a painter herself). The work of the Impressionists and Post-Impressionists is supremely well represented at the Musée d'Orsay (page 87).

For all the innovations of the Post-Impressionists, they still retained allegiance to the idea that painting was closely linked to the things that we see in the real world (the same can be said of the greatest sculptor of the age, Auguste Rodin). However, in a ferment of artistic activity in the early years of the twentieth century this idea was challenged and finally overthrown. Between 1905 and the outbreak of the World War One in 1914 there was an extraordinary outburst of experimentation in painting, beginning with the Fauves, who used colour in a startlingly unnaturalistic way. The leader of the group was Henri Matisse, who startled the art world by painting a green stripe down the centre of a woman's head in one of his portraits. It did not represent anything; it simply looked visually arresting.

Most revolutionary of all were the Cubists led by Pablo Picasso (a Spaniard who settled in Paris in 1901) and Georges Braque. They depicted objects broken into a multiplicity of facets, representing in effect several views of the same thing simultaneously. Cubism spawned a whole host of other 'isms' and was one of the sources of abstraction, which emerged more or less at the same time in Paris and several other places in about 1910. Picasso and Braque worked so closely together during their Cubist period that it is sometimes difficult to distinguish the hand of one from the other, but their collaboration was broken up by the World War One (during which Braque was severely wounded). Afterwards Braque concentrated on subtle variations of his pre-war work, but Picasso continued to experiment vigorously and remained for many years in the forefront of new ideas. His unrivalled output is well represented in Paris, both at the Pompidou Centre (page 18) and at the Musée Picasso (page 113).

Paris continued to be the international centre of the art world in the period between the two world wars. Indeed the roster of great artists working in the city in this period features fewer native-born Frenchmen than foreigners. They included Brancusi (Rumanian), Chagall (Russian), Dali (Spanish), Ernst (German), Modigliani (Italian), Mondrian (Dutch) and Soutine (Lithuanian). The term Ecole de Paris is sometimes used to describe this international artistic community.

The main artistic movement to be spawned by the World War One was Dada, which expressed dismay and disillusionment through the use of the absurd and the irrational (the name itself is said to have been chosen at random from a dictionary). It was more a literary movement than one that found expression in the visual arts, but it was one of the sources of

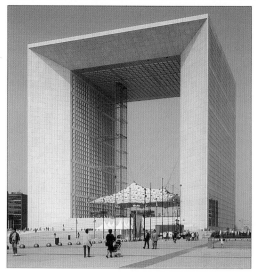

16. Otto von Spreckelsen, La Grande Arche at La Defense, 1989

Surrealism, which was the most widely-spread and influential artistic movement of the 1920s and 1930s. Whereas Dada flourished equally in several countries, Surrealism was very much based in Paris. The founder and principal spokesman of the movement was the French poet André Breton, but its most famous exponent (partly because of his immense talent for self-publicity) was the Spanish painter Salvador Dali. He referred to his paintings as 'hand-painted dream photographs', an apt description of their combination of strange, irrational images and minute depiction of detail.

World War Two caused a great exodus of artists from Paris (although Picasso remained there defiantly during the German occupation). Many artists went to the USA and after the war New York quickly emerged as the world's most exciting centre of avant-garde art and for the first time ever American painting (specifically Abstract Expressionsim) began to influence Europe rather than the other way around. However, there has been a remarkable resurgence in the Paris art world since the 1970s and in spectacular building projects it can be said to lead the world. The most famous building in the context of art is undoubtedly the Pompidou Centre (page 18), which quickly became one of the leading tourist attractions in the world. Also one of the unmissable sights of the city is the controversial glass pyramid in the courtyard of the Louvre, designed by the Chinese-American architect I.M. Pei. Queues waiting to enter the Louvre can watch the absailing window cleaners.The elegant Institut du Monde Arabe (page 29), designed by the French Jean Nouvel, has been widely acclaimed. Two kilometres west of the Arc de Triomphe, the huge arch at La Defense by Otto von Spreckelsen gives a futuristic echo of its classical predecessor (16). On the outskirts of Paris, the Parc de la Villette, designed by Bernard Tschumi, is a conversion, in which the former slaughterhouses and cattlemarket of the city have been transformed into a science park. The attractions of the Parc de la Villette include a museum of science and technology with touch button wizardry, a state-of-the-art playground and a geode – a giant entertainment dome that contains a gigantic cinema screen featuring virtual reality visual and aural effects.

ART

IN

FOCUS

Museums

Paintings

Applied Arts

Architecture

 # CENTRE GEORGES POMPIDOU

CENTRE GEORGES POMPIDOU

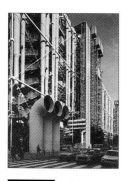

Address
(Beaubourg)
Rue de Renard, Paris 4e
© 44 78 12 33

Map reference
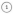

How to get there
Metro: Rambuteau,
Hotel de Ville, Châtelet
Bus: 38, 47, 72, 76, 85
RER: Chatelet-les-Halles

Opening times
Mon, Wed–Fri 12–10; Sat,
Sun and Bank Holidays
10–10. Closed Tue and 1
May.

Entrance fee
Permanent collection: 30F,
20F reduced entry.
Free Sun 10–2. 50F pass for
museum and temporary
exhibitions. Entry to the
building is free.

The Collections
The building contains one of the most important collections of modern art in the world. The primary 'isms' of the twentieth century are well represented, from Fauvism, Cubism, and Surrealism through to the works of contemporary artists. The collection is strong on the major French twentieth-century artists and on foreign artists working in Paris during the first half of this century.

It is sensible to begin a visit to the Pompidou Centre by taking the escalator straight to the fourth floor, turning right, and gradually working your way towards the other end of the floor. Chronologically the collection starts where the Musée d'Orsay ends, with Fauvist works by Matisse, Vlaminck and Derain, painted in the first two decades of this century. The later part of the century is represented at the far end of this floor, where European works are shown with those by important American artists including Rothko, Stella, Twombly, Newman, Warhol and Oldenburg.

There are three-dimensional works by Dadaist and Surrealist artists, and some very lovely wire constructions by Calder, as well as sculptures by Giacometti and Brancusi, and larger pieces by Henry Moore and others on the terrace outside. Picasso is particularly well-represented through every decade of his working life.

The third floor exhibits later and contemporary works, and the display is changed on a regular basis. The museum exhibits around 800 of its 30,000 works, and frequently lends them out. The Pompidou Centre also contains the vast Public Information Library which has sections on the first three floors. It is free and accessible to every visitor and contains books, images, slides, films, videos and the most up-to-date information technology. The top floor is given over to temporary exhibitions, a cinema, a restaurant and a terrace with a stupendous view of the city.

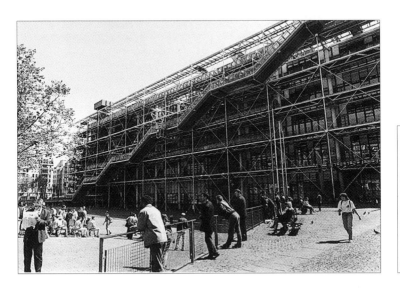

Built in the 1970s the Pompidou Centre, also known as Beaubourg, has excited controversy since its inception. Rather than try to appeal to the traditional museum visitor, the architects, Richard Rogers and Renzo Piano, attempted to make a building which was an attraction in itself, the sort of place which would intrigue those who did not normally visit art galleries. The piazza in front of the museum entrance was designed as a focus for street life. Here fire eaters, sword swallowers and conjurors perform for an audience happy to watch a piece of street theatre.

The idea behind this is that the museum is made more approachable, and people feel tempted to investigate. Design features for this building were made as radical as possible. It is most frequently described as a building turned inside out, with the inner workings displayed in brightly coloured tubes on the exterior. The air ducts are blue, the water ducts green, those carrying electricity yellow and the escalators are red. While the exposure of the inner workings of the building may have been a gimmick, the idea of deliberately placing the escalators on the outside was not, since visitors get a staggering view of the centre of the city as they ascend. It is one of the capital's great delights to view an increasingly widening vista of Paris from its very heart. The museum has proved a huge success with many Parisians visiting it weekly. Twice as many residents come to the Pompidou Centre than visit the Louvre.

Decorative Figure against an Oriental Background

1925–26

Henri Matisse

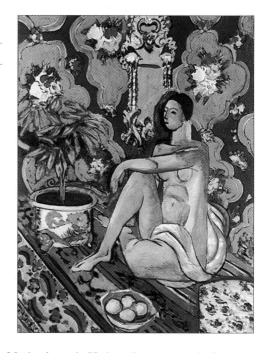

The museum is rich in Matisse's work. He is well represented – from the early Fauve works to the late gouache cut-outs including the very beautiful *Tristesse du Roi* on the wall as you enter this floor. Matisse (1869–1954) is the great twentieth-century colourist whose art is entirely at variance with either the social or formal concerns. As Matisse put it: 'What I dream of is an art of balance, purity and serenity, devoid of troubling or depressing subject matter…a mental soother, something like a good arm-chair in which to rest from physical fatigue'.

Expression through colour is one of the principal characteristics of Matisse's painting. The other major trait is his treatment of space. Within the framework of his canvas he invented ways of transforming perspectives on the surface of the canvas and abolished the distinctions between subject and background so that each area whether flesh or fabric becomes a source of light and colour. In this painting Matisse places a highly sculptural figure against a system of structured lines and strong colours, in this case turquoise, which is a traditionally Oriental colour, mixed with gold and brown. The floor is not horizontal and appears to run into the wall. The symmetrical bowl of lemons centre front seems to support the whole gloriously rich composition.

Léger's work shows a wholehearted embrace of the modern world and a quest to create a heroic modern ideal. His geometric cones and cylinders reflect his admiration for Cézanne, and his association with Picasso and Braque led to a curvilinear variant of Cubism. His massive, often robotic shapes possess an intensity and sense of compression derived from the close-up effect of his compositions in which solid tubular shapes lock together in a machine-like way. The sense of power is enhanced by his bold simple handling of colour and the heavy black outlines which may reflect his training in a stained-glass workshop.

Léger (1881–1955) extolled the beauty of the machine, as did the Italian Futurists immediately before World War One, and was to develop this search for a machine aesthetic with the architect Le Corbusier, with whom he associated around 1920. His subject matter is frequently drawn from the circus and fair, and stylized into machine-made shapes where figures with tubular limbs lock in cog-like patterns. These acrobats were painted in America to where he fled in 1942, and where he lived and taught for five years. He was tremendously impressed by America's 'vitality, its litter and its waste.' In fact he stated categorically that 'Bad taste is one of America's valuable raw materials.' In this respect he was a proto-Pop artist.

With the Black Arc

1912

Wassily Kandinsky

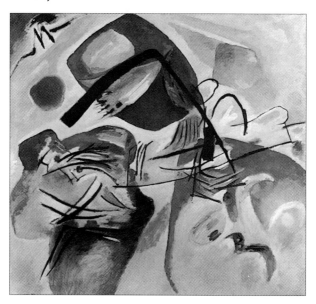

Wassily Kandinsky (1866–1944), who abandoned a legal career in Moscow to train as an artist in Munich, is one of the key figures in modern abstract art. A year in Paris during 1906–07 introduced him to the work of the Fauves, whose bright colour liberated from naturalism, profoundly affected him. He was to develop the impact of this experience on his return to Munich in 1908, becoming increasingly interested in the role of colour as the sole means of expression. Taking the analogy of music, where sound affects the emotions independently of rational thought, Kandinsky sought to approximate the purity of a musical response in painting. He became convinced that this was an important direction in the arts, one which would lead to development in a hitherto unexplored region of visual aesthetics. His highly influential *Concerning the Spiritual in Art* investigates the spiritual and emotional role of colour which he had developed in his German Expressionist Blue Rider Group. His 'first faint doubt as to the importance of an object in painting' was born in him on seeing Monet's colour-rich *Haystack* series. A second such event occurred when he was 'suddenly confronted with a picture of indescribable loveliness… The painting lacked all subject…finally I recognized it as being one of my own standing on its side.' This was the final proof of the need to eliminate the object in favour of 'pure painting', and Kandinsky thenceforth developed the absolute values of colour and form in his work.

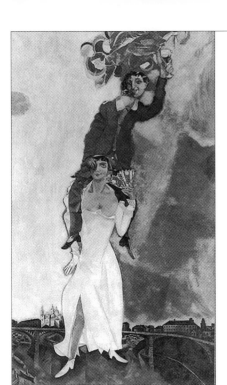

CENTRE GEORGES POMPIDOU

Marc Chagall (1887–1985) came to Paris at the age of twenty-three, but the Russia of his childhood and the memories of his native Vitebsk remained the mainspring of his creativity. He continued painting bouquets of memories and dreams. Through his folkloric images, expressed with an illogical childlike disregard for orthodox naturalism or perspective, he allows us to enter his visionary world. This painting, made when he was thirty, gaily celebrates Chagall's wedding anniversary. It is full of warmth and humour. A golden halo hovers over the little town of Vitebsk and his wife Bella floats in a beautiful white robe. Although Chagall arrived in Paris at a critical moment in the history of art, he was not swept up by the avant-gardists' move towards abstraction. Apollinaire, friend of the Cubists, preferred the poetic evocations of Chirico and Chagall. Neither artist abandoned the figurative style though both subverted it, and in this respect were both highly important for the Surrealists.

Chagall recalls his images of times past in random order and form: figures, horses and blue violins continue to float upwards, defying gravity and reaching for the bluest of Heavens. The humanity of his work is reflected in his remark that 'everything can change in this world of ours, except the heart of man and his aspiration towards knowledge of the Divine.'

Sylvia von Harden

1926

Otto Dix

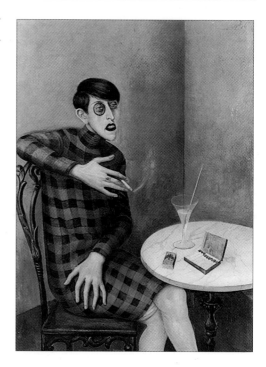

This unforgiving hard-edged portrait of the journalist Sylvia von Harden by Otto Dix (1891–1969) is an example of the *Neue Sachlichkeit* or New Realism employed by the Berlin Dadaists in the 1920s as a suitable medium for political satire. The approach was retained even in portraiture, creating an exaggeratedly naturalistic style in the manner of the German primitives. In 1937 eight of Dix's paintings were included in the National Socialist Exhibition of Degenerate Art, and in the same year 260 of his works removed from German museums. Hitler declared the movement decadent and their works were proscribed.

Portraiture was the central theme of Dix's work. Like many of his mercilessly probing studies, this unflattering, stylized portrait is an extraordinarily memorable image. The sitter, a bony-faced, short-haired emancipated woman in a monacle and lipstick, is shown alone, smoking in a café. The pitiless focusing on the large, expressive hands, the stocking top revealed by her short dress, and the open mouth of an adenoidal breather call to mind the closely observed images by Bosch and Bruegel of the persecutors of the crucified Christ. Sharp reds add to the aggressive nature of this work.

**Premonitory
Portrait of
Guillaume
Apollinaire**

1914

Giorgio de Chirico

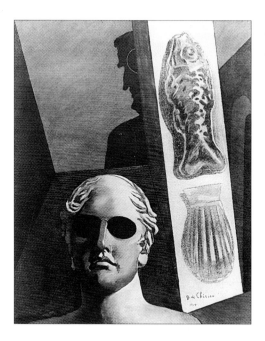

Born in Greece of Italian parents, Chirico (1888–1978) trained in Athens and Munich before arriving in Paris in 1911, where he first came to prominence when he made a series of townscapes of deserted squares and empty arcades. In Ferrara in 1917 he met the Italian Futurist Carlo Carrà, and together they developed an aesthetic termed Metaphysical Painting, creating works of mystery and poetic alienation, of melancholy and uneasy menace. The uncanny quiet and potent emptiness of this picture possess the quality of an anxious dream.

Chirico drew deeply on his Italian heritage, using the fifteenth-century invention of deep linear perspective and the architecture of the arcaded piazza. His work was a seminal influence on Magritte and the Surrealists, and attracted the poet and high priest of Surrealism, Guillaume Apollinaire, who saw it for the first time in 1912. This portrait was begun the following year. The foreground device of a poet's bust suggests the blind Homer, linking the sitter to the Classical poet and the painter to his Hellenic birthplace. Apollinaire is shown in silhouette as a figure in a fairground shooting gallery. The white outline painted over the top front of Apollinaire's profile marks the exact spot where, four years later in World War One, the poet received a head wound. This convinced Apollinaire of its premonitory nature.

Le Modèle Rouge

1935

René Magritte

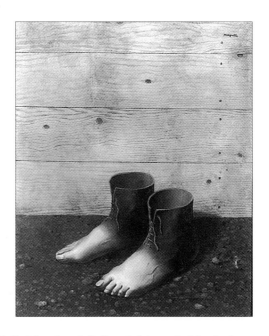

Alongside Salvador Dali, Magritte (1898–1967) is probably the best known Surrealist, but while Dali's images are frequently disgusting and nightmarish, Magritte's show disturbing everyday objects – mirrors reflect the wrong image, easel paintings open into the background, or the painted sea becomes the actual sea. Magritte was tremendously affected by Giorgio de Chirico's work, saying that it was a 'new vision, in which the viewer rediscovers his isolation and hears the silence of the world.' Magritte developed the troubled dream-like quality of Chirico's pictures but not their poetic melancholy. Magritte's work gives off a funereal lugubriousness which may stem from the adolescent trauma of seeing his mother's veiled body which had been dredged from the river after her suicide. The recurrent images of the veil, tomb-like granite, the drowned fish/woman and the man asleep in a coffin all draw on this event.

A retiring, quiet man, Magritte spent almost all his life in an obscure suburb of Brussels, apart from three years in Paris between 1927 and 1930 when Surrealism was the prominent avant-garde art movement. In the *Modèle Rouge*, where the title has no apparent reference to the painting, the viewer is encouraged to read the painting in the light of the title, so that title and image gain a new significance in the true Surrealist manner. The harsh gravel against the fleshy bare feet which mutate into empty leather boots was an image the artist returned to several times.

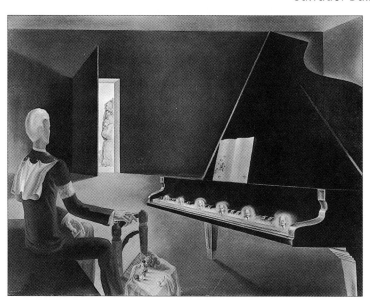

Salvador Dali (1904–89), the self-publicist with the bulging eyes and waxed moustache, was the Surrealist *par excellence*. Expelled from the movement in 1938 for his right-wing political views, he embodies the essentials of Surrealism like no other 'official' member. He was a Surrealist by nature and inclination. 'The difference between me and the Surrealists is that I am a Surrealist' was his summing up of the rift. Dali's work shows the combination of his photographically realistic technique with his bizarre and hallucinatory images. It embodies the Surrealist principle which defined beauty as shocking or 'convulsive'; a beauty created by unexpected juxtapositions of objects, like 'the chance encounter on the dissecting table of the umbrella and the sewing machine.' Freud's *Interpretation of Dreams* was of paramount importance. Dali maintained that 'the subconscious has a symbolic language that is truly a universal language for it does not depend on education or culture or intelligence but speaks with the vocabulary of the great vital constants, sexual instinct, sense of death, physical notion of the enigma of space – these vital constants are universally echoed in every human being.' This painting, which defies definition, encapsulates in its unexpected arrangement of objects not usually seen together Lautréamont's definition of 'convulsive beauty'.

THE EIFFEL TOWER
Built 1889

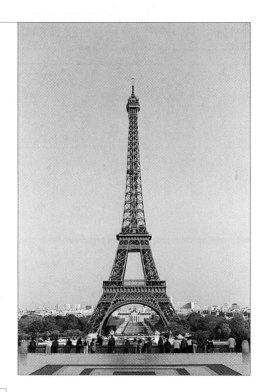

Address
Champs de Mars, Paris 7e
✆ 44 11 23 j23

Map reference
②

How to get there
Metro: Bir Hakeim
Bus: 42, 69, 72, 82

Opening times
Via lift: Jan to Mar, 9.30–11
pm; Mar to July 9–11pm;
Julyto Sept 9–midnight;
Sept to Dec 9–11pm; Last
adm. 1 hr before closing.

Entrance fee
Lift to 1st platform 20F; 2nd
platform 36F; 3rd platform
53F. Staircase to 2nd
platform 12F. Discounts for
children and groups.

The Eiffel Tower has become an enduring symbol of the city of Paris, but it was originally intended as a temporary structure to commemorate the centenary of the Revolution. The tower was saved from demolition some twenty years later when it was realized that its great height would enable it to provide an antenna for radiotelegraphic purposes. The design was selected by a competition which was won by Gustave Eiffel, an engineer who had experience of constructing high level railway viaducts. The tower has been feared, celebrated and loathed in equal measure: during its construction, local residents became convinced that it would collapse, and Eiffel had to personally assure them that it would not. The author Guy de Maupassant left Paris permanently to avoid looking at its 'metallic carcass' but others who espoused more self-consciously modern views championed the tower: Seurat and Douanier Rousseau were among the first to paint it, in 1889 and 1890 respectively. On a clear day, it is possible to see Chartres Cathedral from the high level viewing platform.

Built 1987

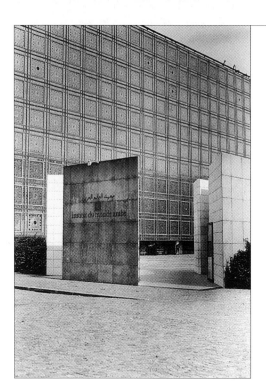

Built in 1987 by the French architect Jean Nouvel as a centre for the advancement of Arab culture and the fostering of Franco-Arab relations, this building combines modern materials and techniques with references to traditional Arab architecture. Thus the curved, street-facing section suggests a scimitar, and the white tower which houses the library calls to mind a minaret or Tower of Babel. The geometric patterning seen in carved wooden screens on Arab buildings is reflected on the south facade. Here 240 high-tech metal screens, each containing a central iris framed by twenty smaller irises each made up of interlocking blades, are electronically controlled to open and close like camera lenses according to the sunlight outside. The four sides of the inner courtyard contain riveted alabaster panels creating a mirage-like effect even on gloomy days. A glass lift offers the delightful opportunity for visitors to see through the heart of the building. The museum on the seventh floor contains Islamic works of art and culture from the ninth to the nineteenth century.

Address
1 rue des Fosses-St-Bernard, Paris 5e
© 40 51 38 38

Map reference

How to get there
Metro: Jussieu, Cardinal Lemoine.

Opening times
Tue to Sun 10–6.
Closed Mon.

Entrance fee
25F adults. 20F children and pensioners.

Begun 1671

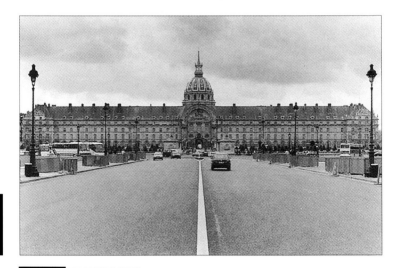

Address
Avenue de Tourville,
Paris 7e
✆ 44 42 37 72

Map reference
④

How to get there
Metro: Latour-Maubourg,
Varenne.
RER: Invalides
Buses: 32, 63, 93

Opening times
Oct–March 10–5 daily
April–Sept 10–6 daily

Entrance fee
27F adults, 14F for students.

As the name suggests, this monument was founded for soldiers invalided out of the army. To eradicate a system which reduced disabled soldiers to beggary, Louis XIV founded Les Invalides in 1670. The vast edifice, able to house 4,000 men, was also a monument to the Sun King's own glory. Begun according to plans by Liberal Bruant in 1671, the building centres around the Dome Church which took twenty-seven years to build. Its crypt now houses Napoleon's remains, exhumed from the island of St. Helena nineteen years after his death, and brought here with great ceremony for a funeral on 15 December 1840. The Esplanade leads from the Quai d'Orsay through a formal garden to the the majestic facade of Les Invalides. In an arch above the large central portal is an equestrian portrait of the Sun King supported by Prudence and Justice. Behind this is the splendid *cour d'honneur* which now houses the Army Museum in its north-west wing. Les Invalides is once again restored to its original function as a hospital for veterans.

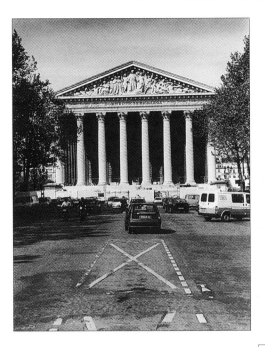

The church of St. Mary Magdalene, known as La Madeleine, stands at the top of an imposing sweep of steps facing the rue Royale, commanding a view towards the Place de la Concorde. After many vicissitudes and changes of plan the present building is now a windowless edifice with a Greek temple facade of Corinthian columns. Work on the church was begun in 1764 but after the death of the architect in 1777 a new scheme was considered, and a Greek-cross building begun. Well before its completion the revolutionary government dreamt up more rational uses for the building in progress. Napoleon decided on a Temple of Glory dedicated to the Great Army and in 1806 commissioned Barthélemy Vignon to build it. After the erection of the colonnades, Louis XVIII, restored to power in 1814, ordered that the temple be once more a church. The interior, in contrast to the exterior, is lavishly overdecorated. At the east end a series of frescoes celebrates heroes of Christianity in a span which includes, of all unlikely candidates, Napoleon. The building was consecrated in 1842 by a priest who was later shot by the Commune in 1871.

Address
Place de la Madeleine, 8e
℅ 42 65 52 17

Map reference

How to get there
Metro: Madeleine

Opening times
Mon to Sat 7–7; Sun 8–1.30 and 3.30–7.

31

Address

293 Avenue Daumesnil,
Paris 12e

✆ 44 74 84 80

Map reference

How to get there

Metro: Porte Dorée.

Opening times

Weekdays 10–12 and
1.30–5.30. Sat and Sun
12.30–6. Closed Tue.

Entrance fee

27F adults, 18F reductions.

The museum is situated at the north-west side of the forest of Vincennes in a building designed for the Colonial Exhibition in 1931. Originally called the Museum of the Colonies, and later the Museum of Overseas France, its facade contains a frieze depicting the contributions made by France's overseas colonies. It houses one of the best collections of African and Oceanic art in Europe, not all of it from former French colonies. On one side of the ground floor is a display of Oceanic art such as Australian painted bark, drums, masks, funerary figures and root sculptures from New Guinea. The other side of the main hall contains African art including the masks which made such an impact on artists like Picasso and Braque at the beginning of the century. There are also copper and wood figures. The African collection continues on the two upper floors. The first floor has dance and ceremonial masks from the Ivory Coast, Mali and Ghana, and ceremonial statues from the Congo. The upper floor contains work from the former French colonies of north Africa such as Morocco, Algeria and Tunisia. Here are jewellery, ceramics, embroidery, pottery, furniture and carpets. In the basement of this building, which is just opposite the zoo, is a tropical aquarium and terrariums with crocodiles and tortoises.

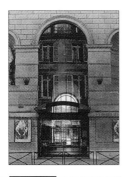

Musée des Arts Décoratifs

In the north wing of the Louvre on the rue de Rivoli are three museums; that of decorative arts; a recently opened museum of fashion; and a museum of advertising, the Musée de la Publicité, which displays part of its collection of 50,000 posters. The largest of these three is the Musée des Arts Décoratifs, founded in 1877. It has four floors of furnishings, porcelain, and silverware tracing the changes in style and taste from the Middle Ages to the present day. The first floor houses the modern collection including very fine Art Nouveau and Art Deco work; the latter is well-represented by a reconstruction of the rooms of the great couturier Jeanne Lanvin. Other floors contain rooms arranged with objects from the time of the Sun King to the Second Empire. There is also a large collection of toys, dolls and posters.

Musée des Arts de la Mode

Alongside the museum of decorative arts is this museum dedicated to fashion. Opened in 1986 its five floors are devoted to the display of what France recognizes to be an art form and an important part of the country's heritage. The first floor shows changing exhibitions of the permanent collection. The upper three floors house examples of the work of famous couturiers. There is also a large collection of costume going back to the sixteenth century. The museum contains a library, a workshop where costumes are restored, and the Institut de la Mode, which runs design courses. For those interested in the evolution of fashion, the Musée de la Mode et du Costume at the Palais Galliéra in the 16e contains over 100,000 outfits from the eighteenth to the present century.

Address
Musée des Arts Décoratifs;
Musée des Arts de la Mode,
Palais du Louvre
107 rue de Rivoli, Paris 1e
✆ 44 55 57 50

Map reference

How to get there
Metro: Palais-Royal,
Tuileries.

Opening times
(Musée des Arts Décoratifs)
Wed to Sat 12.30–6; Sun
12–6. Closed Mon and Tue
(Musée des Arts de la
Mode) open only during
temporary exhibitions.

Entrance fee
(Musée des Arts Décoratifs)
20F, 15F for students and
over-60s.
(Musée des Arts de la
Mode) 20F.

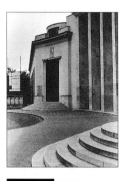

Address

11 Avenue du Président
Wilson, Paris 16e

✆ 47 23 61 27

Map reference

⑧

How to get there

Metro: Iéna

Opening times

Tue to Fri 10–5.30; Sat and
Sun 10–7. Closed Mon.
Hours depend on individual
exhibition.

Entrance fee

28F, 18F reductions. Prices
vary according to exhibition.

Built in 1937 for the World Fair, the two parts of this building are linked by a white stone portico. It was named the Palais de Tokyo after the facing quai. The walls of the terrace are decorated with reliefs by Janniot and with statues by Bourdelle including *La France*, in memory of the patriots killed in World War Two. The east wing now contains a collection of modern art, from the turn of the century to the present day. Although it has now been eclipsed by the Pompidou Centre, this melacholy gem is well worth visiting for its selection of the major art movements of the twentieth century. Dufy's giant homage to the spirit of electricity occupies the whole of a room facing the entrance. There are Rouault's *Prostitutes*, Fauve works by Derain, Vlaminck, Bonnard and Matisse; Cubist works by Braque and Picasso; and the Orphic art of Sonia and Robert Delaunay. Also on show are works by Modigliani, the Purists, the Metaphysical School, Dadaists and Surrealists. There are some very fine canvases by less celebrated artists including Metzinger, Lhote and Gleizes. The upper floors host temporary exhibitions and a variety of experimental and contemporary work.

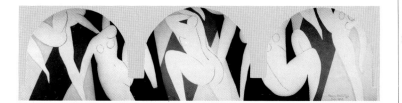

Matisse's *Dance* was conceived as a decoration with a particular site in mind – the Barnes Foundation at Meryon near Philadelphia. The very day that Matisse (1869–1954) arrived to see forty of his paintings which Dr Albert Barnes, the patent-medicine millionaire, had bought and hung in the Foundation alongside works by Cézanne, Renoir and Seurat, his attention was drawn to a vast wall space above the french windows which he was invited to decorate. The vastness of scale was something he had never tackled and he may have felt that the challenge would give new inspiration to his painting. Back in Nice, in the largest space he could find – a former film studio – he set to work. In choosing to illustrate dance he was returning to a theme he had painted for the Russian collector Sergei Shchukin. However, this work is more energetic; a dance of revelry which recalls the frenzied Bacchanals and Arcadian idylls of the Old Masters.

The vast size of the picture meant that Matisse had to experiment with two techniques that were to prove important in his subsequent work. The first was the use of charcoal tied to a long pole to obviate climbing up ladders; it allowed the creation of fluid line not usually seen in large pictures. The second was the use of cut-out painted paper to experiment with colour schemes; this avoided the overpainting of large areas during the experimentation phase. The process was taken up in Matisse's later paper cut-out collages. When *Dance* was shipped over to the U.S., it was discovered that Matisse had been given the wrong dimensions and that the work did not fit. Rather than insert extra canvas and patch up the job, he began again on the second version now in the Barnes Foundation.

La Ville de Paris

1910–12

Robert Delaunay

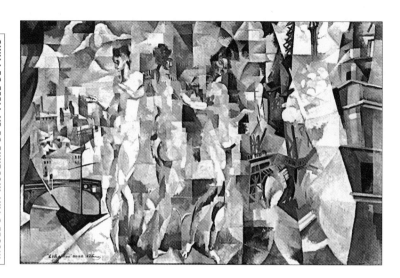

In 1911 Delaunay (1885–1941) took a studio with a roof-top window with a view over Paris: the chequerboard of vibrating coloured patches in this picture can be read as roof tops, chimneys and windows. This painting was hailed by Guillaume Apollinaire at the 1912 Salon des Indépendants as the most important item on show. Delaunay was later to say of it that it marked a transition between painting of the past and that of the new. The art of the new is evident in the treatment of the painting where forms are fractured. The subject matter itself draws together the old and the new: the Eiffel Tower, the great modern symbol of the city of Paris, is reassembled on the right of the canvas at the centre of which the female nudes recall Botticelli's Three Graces from the *Primavera.* The bridge and curtain on the left are a homage to Delaunay's friend Henri (Douanier) Rousseau who had died in 1910, and were both used in one of Rousseau's self-portraits. Intensely interested in the colour theories formulated by the Neo-Impressionists and their investigation into Chevreuil's colour theories, Delaunay made colour the principal feature of his work, and the year after he finished this canvas he began a series of Discs and Cosmic Circular Forms which are among the first pure abstract paintings; there are examples of these in the museum. The work of Robert's wife Sonia is also well represented. In Delaunay's own words he 'played with colour as one may express onself in music, by a fugue of coloured phrases'.

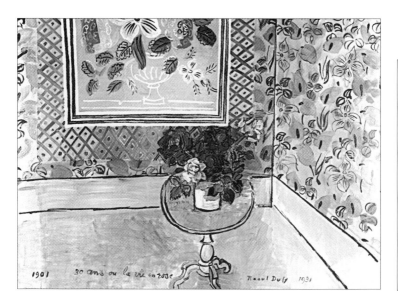

This work is a good illustration of the style which made Dufy (1877–1953) famous in its use of simplified, often child-like forms, and bright colour, which he derived from Matisse and the Fauves. The artist's skill at translating the pleasure of life into painting made him a popular textile designer as well as a painter. No society lady of the period was without her Dufy print curtains or sofa. This pink monochrome work enlived with touches of blue, green and yellow is inscribed at the bottom *1901 30 years or life in pink Raoul Dufy 1931*, a pretty dedication not attributable to anything more than a celebration of youth and happiness.

In contrast to this work is Dufy's huge *Spirit of Electricity* of 1937 which also hangs in the museum. Executed for the Pavilion of Light at the International Exhibition of 1937, its 250 panels glorify the history of light from its origins to the 1930s. Dufy has chronologically represented 110 personalities from the gods of Olympus at the top to Edison.

Nude in the Bath

1937

Pierre Bonnard

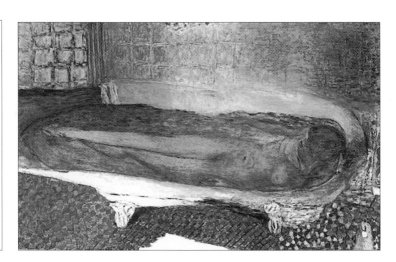

Bonnard (1867–1947), after failing his law exams, studied at the Ecole des Beaux-Arts before entering the Académie Julian where he met Denis, Sérusier, Vuillard and Ranson, the group of artists who formed the Nabis. Bonnard shared little interest in the literary or intellectual aspect of the Nabis. The essential link between him and them was his skill as a designer and decorator, an area he was very active in from 1891 to 1905, designing screens, posters and lithographs. His painting career developed from his decorative panels and screens.

Like Vuillard, Bonnard was stirred by simple scenes of domestic life, and from 1925 began to paint the great nude and bath scenes for which he is chiefly remembered. The woman Bonnard painted time and time again was Marie Boursin whom he met in 1894 and with whom he lived for thirty years before marrying. Known as Marthe, she was apparently a nagging neurotic who cared nothing for painting, who could not cook and who made Bonnard's life miserable. Yet he painted her repeatedly as the ageless muse of the domestic bath, her irridescent skin beneath the water's surface fusing into the coloured light reflected from the tiled room.

(MUSÉE HISTORIQUE DE LA VILLE DE PARIS)

The Musée Carnavalet is situated in the low-lying area of Paris known as the Marais (swamp), which escaped the attentions of Baron Haussmann in the nineteenth century, and where consequently much beautiful sixteenth- and seventeenth-century architecture is to be found. The museum is devoted to the history of the city. It houses an extensive collection of prints and photographs as well as innumerable works of art, sculptures, medals, furniture and paintings. Views of Paris alternate with portraits and scenes of the period. There are also personal souvenirs of the great figures in the history of the city, and a Revolutionary section given over to paintings, mementoes and objects. Among the very fine portraits is Gerard's *Madame Récamier*, commissioned immediately after the sitter rejected David's picture, now in the Louvre.

The building itself is of note: although it was built in 1548 for Jacques de Ligneris, who was President of the Parlement, it was extensively remodelled in 1660 by the architect François Mansart, who incorporated the earlier sixteenth-century work of the sculptor Jean Goujon in his façade, still visible today. The name Carnavalet is a Parisian mangling of the surname of a Breton called Kernevenoch or Kernevenoy, whose widow took possession of the house in 1578. One of Goujon's sculptures, originally an allegorical figure of Abundance, has been reworked as a carnival mask to provide a punning reference to the mansion's name. The museum has recently been extended, and linked to the neighbouring mansion, the Hôtel le Peletier de Saint-Fargeau. The original interior of the museum no longer exists; it has been replaced with panelling and ceiling paintings from seventeenth- and eighteenth-century Parisian houses.

Address

23 rue Sevignée, Paris 4e

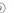 44 59 29 40

Map reference

⑨

How to get there

Metro: St Paul

Opening times

Tue to Sun 9.30–5.30. Closed Mon.

Entrance fee

15F, 8.50F reductions.

Madame de Sévigné

c. 1670

Claude Lefebvre

Undoubtedly the most illustrious resident of the Hôtel Carnavalet was Madame de Sévigné, who lived here from 1677 until her death in 1696. Here she maintained one of the most brilliant salons in the whole of Paris, where she elevated conversation to the level of an art form. The quality of her conversation survives in her letters, which were circulated privately in her own lifetime and can still be read with great enjoyment today. Madame de Sévigné's husband died when she was only twenty-five, but she took full advantage of the independence this afforded her. The letters show a fear-less intelligence, a capacity for irony and a clearsighted awareness of the world at large.

A special room in the museum is devoted to her memory. The collec-tion is fortunate in having this breathtaking portrait of her by Lefebvre (1637–75) as well as another in pastels by Nanteuil and a portrait by Pierre Mignard of her daughter, the Comtesse de Grignan, whose marriage and subsequent absence caused most of the letters to be written. The muse-um also houses a beautiful japanned desk used by Madame de Sévigné, which she brought with her from the Château des Rochers.

This museum is built on the site of the Roman thermal baths of Lutetia, dating from the second or third century. The west side still stands and is one of the most remarkable Gallo-Roman monuments. In the Middle Ages houses were built into the partially ruined building. At the end of the fifteenth century the present edifice was erected on the Roman foundations and walls. In the nineteenth century the interior was reworked and windows were put into the main body of the building. The collection was assembled by Alexandre du Sommerard and his exhibits of armour, chests, ivories, mirrors and hangings became a pilgramage for those interested in the cultish assemblage of the medieval and Renaissance. This collection was later increased by another one of stone work. It was, however, Sommerard's son who was the real founder of the museum, not only as curator but also as collector. The most internationally renowned pieces were gathered together under his stewardship. Today the collection encompasses a number of tapestries, including the famous *Lady with a Unicorn* series, stained glass, mostly French and from the twelfth and thirteenth centuries, carvings and sculpture and jewellery. In the Gallery of the Kings there is a display of the heads and headless figures from Notre Dame.

Address
6 Pl Paul Painlevé, Paris 5e
✆ 43 25 62 00

Map reference
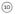

How to get there
Metro: St-Michel, Cluny and Odéon
Buses: 63, 86, 87, 21, 27, 85, 38
RER: St-Michel

Opening times
9.15–5.45 daily
Closed Tue.

Entrance fee
27F, 18F reduced price tickets. Under 18s free

Tours
Guided visits; children's activities; concerts of medieval music.

MUSÉE DE CLUNY

Lady with a Unicorn Tapestries
Late fifteenth-century

The highlight of the Musée de Cluny's collection is the famed series of late fifteenth-century tapestries known as *The Lady with a Unicorn* or *The Five Senses*. All the tapestries have a soft red background, liberally festooned with sprays of flowers. Sets of tapestries with an allegorical, secular meaning were very popular in the fifteenth and sixteenth centuries. The fact that this series has survived at all is astonishing: at one stage they were used to wrap potatoes, and at another they were used to reline curtains! The most probable interpretation of the designs is that they refer to the five senses: in *Sight*, the Lady shows the unicorn its reflection in the mirror; in *Hearing* there is a delightful depiction of a chamber organ; *Smell* is represented by the Lady making a garland of flowers; in *Taste* the Lady selects delicacies while a monkey at her feet puts something into his mouth, and in the allegory of *Touch* the Lady gently holds the unicorn's horn. The meaning of the sixth tapestry displayed – *Choosing the Jewels* – is more difficult to unravel, and it is likely that this is a panel which has survived from another series.

Formerly sited in the Boulevard des Capucines, this collection is now housed in the Hôtel de Donon, an exquisite mansion begun in 1575 and altered over the following century. The extension, facade and much of the collection inside is eighteenth-century. Arranged on four floors around a courtyard, the twenty small rooms display the delightful collection assembled by Ernst Cognacq, founder of the Samaritaine department store, and his wife Louise Jay. It was bequeathed to the nation on his death in 1928.

The collection includes paintings by Chardin, Watteau, Boucher, Drouais, Tiepolo, Wright of Derby, Reynolds, Lawrence and very many charming genre scenes. There is also lovely porcelain, statuary, furniture and carpets, all beautifully displayed. The panelling in the first room is from the Château d'Eu in Normandy, that in the third room dates from the seventeenth century and is original to the house. From the entrance a clockwise tour takes one round the small, intimate rooms, the contents of which are clearly but discreetly described on a label, up to the attic where display cabinets contain extraordinary *objets d'art*: a perfume pistol, toilet articles, inlaid boxes, sewing cases, cigar cutters and wrought metalwork scissors. If one mentally blocks out the warders, a visit here offers the experience of being translated back two centuries to a house whose occupants have momentarily left.

Address

8 rue Elzevir, Paris 3e

✆ 40 27 07 21

Map reference

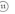

How to get there

Metro: St-Paul

Opening times

10–5.40 Tue–Sun. Closed Mon (last admission 4.30).

Entrance fee

17.50F adults, Students 9F.

Return of Diana after the Chase

1745

François Boucher

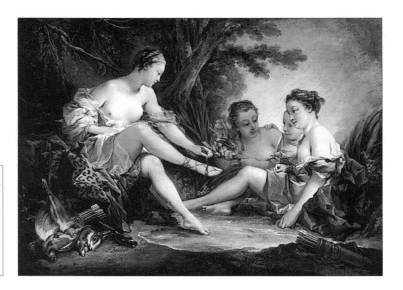

One of four paintings showing the Roman goddess of hunting (two are in London's Wallace Collection, and another in the Los Angeles County Museum), this is highly typical of Boucher (1703–70). For many, Boucher's work embodies the lost charm of the Ancien Régime. Yet the undeniable brilliance of his best work has been darkened by a rash of imitations that compromise the genuine article.

This signed and dated picture shows the virgin goddess returned with the spoils of the chase. Seated on a mossy bank, the toes of one foot in a pool, Diana unties her second sandal while three nymphs or attendants look on. The influence of Correggio, Titian and Rubens is evident here in the sensuous handling of the flesh. But the overall feeling is less vigorous than in the work of those artists. Boucher's skin tones are silvery pink, which with the addition of red adds warmth to the silky flesh. Boucher enjoyed a successful career depicting charming nymphs, shepherdesses and goddesses sporting semi-naked in woodland settings. His works charmed Madame de Pompadour and her entourage and disgusted Diderot, who saw in them proof of moral decay and social corruption.

Eugène Delacroix (1798–1863), known for his dramatic and highly-coloured canvases, chose quiet and solititude in which to work. In 1857 he stopped commuting by train from Champrosay near Fontainebleau to Paris and moved to the then secluded Place Furstenburg, which occupies the former courtyard and cloister of the abbot's palace attached to the Abbey of St Germain des Prés. This move enabled him to be closer to the church of St. Sulpice where he was painting the murals of *Jacob and the Angel* and *Heliodorus driven from the Temple*. He remained here until his death in 1863. The first-floor apartment and garden studio now form a national museum, where regular exhibitions of Delacroix's work are held. Amongst the works he painted here are *The Entombment of Christ* and *The Way to Calvary*, both of which now hang in the museum. There is a portrait of Georges Sand, self-portraits, studies for future works, sketches, etchings, prints, a dozen minor paintings and artistic memorabilia. The charm of the tiny square is reflected in the quiet garden in one of the loveliest corners of the city. The French have honoured the great Romantic artist by placing his portrait on the 100 franc note.

Address
6 rue de Furstenberg,
Paris 6e
 43 54 04 87

Map reference
⑫

How to get there
Metro: St-Germain-des-Prés

Opening times
Wed to Mon 9.45–5.15.
Closed Tue.

Entrance fee
12F adults, 8F students.

MUSÉE DELACROIX

Address
59 Avenue Foch, Paris 16e
℡ 45 53 57 96

Map reference
⑬

How to get there
Metro: Porte Dauphine

Opening times
Thur and Sun 2–6. Open
Bank Holidays except 25
Dec and 1 Jan. Closed Aug.

Entrance fee
Free.

The Musée d'Ennery houses an impressive collection of art from the Far East, originally assembled by the playwright and librettist Adolphe d'Ennery. The museum is situated on the first floor of a Second Empire mansion – on the ground floor is the Armenian Museum. D'Ennery's interest in things Oriental was very much of its time: many Impressionist artists were fascinated both by the different visual conventions found in Japanese prints and by their subject matter. The collection mainly consists of works of art, both Chinese and Japanese, ranging from the seventeenth to the nineteenth centuries. On show are furniture, lacquerwork, ceramics and bronzes, with many delightful carvings of animal and human forms. Display cases with mother-of-pearl inlays contain many hundreds of netsuke, the elaborately carved toggles made of bone, wood or ivory, worn with traditional Japanese dress. These are always miniature in scale, carved in the form of insects, plants and animals, or occasionally figures from literary sources.

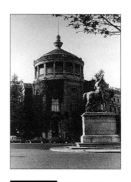

Founded in 1879 in Lyon by Emile Guimet, this museum of Oriental works was presented to the state and transferred to Paris, where it opened in 1889. Officially renamed the Department of Asiatic Arts of the National Museums in 1945, the original collection has expanded to include the Louvre's Asiatic department. On the ground floor is a collection of Far Eastern art including Khmer carved sculpture from Cambodia and statues of gods from Vietnam. There are banners, bronzes and objects of religious ceremony from Java, Siam, Laos and Burma. Tibetan and Nepalese art is represented by paintings, statuary, jewellery and religious objects. The first floor contains a wide-ranging collection of Indian art from the third to the nineteenth centuries. The art of Pakistan and Afghanistan is also represented. There are objects in bronze, jade and lacquer from China, but Chinese ceramics are best represented on the second floor by an exceptional display of eighteenth-century famille rose china acquired from the Calmann and Grandidier collections. Here can also be found jewels from Korea and dance masks from Japan.

Address

6 Pl d'Iéna Paris 16e

✆ 47 23 61 65

Map reference

How to get there

Metro: Iéna, Boissière

Opening times

Wed–Mon 9.45–6.
Closed Tue.

Entrance fee

27F adults; 8F Sunday.

MUSÉE GUIMET

MUSÉE HENNER

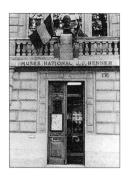

Address
43 Avenue de Villiers,
Paris 17e

℡ 47 63 42 73

Map reference
⑮

How to get there
Metro: Malesherbes

Opening times
Tue–Sun 10–12 and 2–5.
Closed Mon.

Entrance fee
14F, Students 7F.

The museum is devoted to the work of the painter Jean-Jacques Henner (1829–1905). Established by his family fifteen years after his death, the first three floors of this five-storey nineteenth-century mansion are given over to the display of some of the artist's 500 canvases and 1,000 drawings. Born in Bernwiller near Mulhouse in Alsace, he studied initially in Strasbourg before receiving a bursary to attend the Ecole de Beaux-Arts in Paris. Winning the Prix de Rome enabled him to spend five years in Italy, where he was profoundly influenced by the work of Titian and Correggio, as can be seen in the choice and treatment of his mythological subjects. An intimate of Manet and the Impressionist circle, Henner's work does not, however, reflect their style. An official painter who enjoyed considerable public success as both portraitist and landscape artist, his pictures belong to a more mainstream tradition of *fin-de-siècle* Symbolism like those of Gustave Moreau, whom Henner also knew well. However, his success has been eclipsed by the Impressionists and the avant-garde. The museum also contains an audio-visual display about the development of the artist's work.

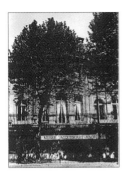

This museum houses a first-rate collection assembled by Edouard André and his wife. Born in Paris in 1833 André was by the age of twenty, tall, handsome and wealthy. He became an officer in the Imperial Guards and one of the most popular men at court. In 1869 he built a grand residence for himself in the newly laid out elegant Boulevard Haussman, which now houses his collection. From 1871 he became an assiduous collector of fine *objets d'art*. A decade later he married the popular Parisian painter Nellie Jacquemart, whose fine eye made her an ideal companion in his search for the rare. Their collection included tapestries, rugs, furniture and manuscripts but principally paintings and sculpture.

After her husband's death in 1894 Nellie Jacquemart continued to collect visiting India, Egypt and Greece in the search for acquisitions. Following her death in 1914 the collection was bequeathed to the Institut de France with the proviso that this museum be created. On view here are some staggering pieces: the house is almost like a mini Louvre exhibiting Italian Renaissance paintings and sculpture by Uccello, Perugino, Mantegna, Carpaccio, Crivelli and Donatello, Flemish work by Memling, Massys and Van Dyck, Dutch paintings by Hals, Rembrandt and Ruisdael, and French paintings by Lancret, Chardin, Boucher, Fragonard and David. On the stairway is Tiepolo's fresco of the *Reception of Henri III in Venice* depicting a stupendous party.

Address

158 Boulevard Haussmann, Paris 8e

✆ 45 62 39 94

Map reference

How to get there

Metro: Miromesnil, St-Philippe-du-Roule

Opening times

Wed to Sun 1–5.30. Closed Mon, Tue and August.

Entrance fee

10F adults.

MUSÉE JACQUEMART ANDRÉ

✪ MUSÉE DU LOUVRE

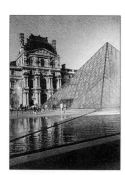

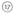

Address
Pyramide (Cour Napoléon)
Palais du Louvre, Paris 1e
✆ 40 20 53 17, 40 20 51 51

Map reference
⑰

How to get there
Metro: Palais-Royal, Louvre.
Buses: 21, 24, 27, 39, 48,
67, 68, 69, 72, 75, 76, 81,
85, 95.
RER: Châtelet les Halles.

Opening times
Thur to Sun 9–6 (last adm.
5.15);Mon and Wed 9am-
10pm (last adm 9.15pm).
Closed Tue. Limited display
and temporary exhibitions
in Hall Napoleon Wed to
Mon 9am–10pm.

Entrance fee
40F. Half price after 5 and
all day Sun, discounts for
18–25s and over 60s. Under
18s free.

Tours
see information desk.

The Collections

The museum is one of the largest in the world and there simply is not time to see its entire contents in one or two visits alone. Its collection, which ranges from Egyptian art of 5000 BC to nineteenth-century work, is divided into seven departments: Oriental and Islamic Antiquities; Egyptian Antiquities; Greek, Roman and Etruscan Antiquities; Painting; Sculpture; Decorative Arts; and Graphic Arts.

The museum comprises three wings: Denon running south along the Seine; Sully to the east, and Richelieu running north along the rue de Rivoli. These three wings are colour coded to help you find your way around. Each level is also colour coded and divided into ten sections and each room is numbered. It sounds organized but it is nevertheless extremely difficult to negotiate the miles of corridors within this building. In 1993 the Museum celebrated the bicentenary of its opening, and an extension to the Richelieu Wing opened to celebrate the event. The upheaval this has caused will affect the building through the decade, so changes and closures are to be expected.

This is one of the greatest art collections in the world. The core collection was formed by François I, and added to by Henri II and Catherine de Médicis. The Old Master collection was developed by Louis XIV and important Spanish and Dutch works acquired by Louis XVI. Most visitors come to view the exceptional collection of European paintings which range from 1400 to 1900. The Grand Gallery running along the south of the building is a stupendous piece of design which showed the world what a picture gallery should look like. Pierced by large windows, its walls are hung with some of the finest works of the Italian Renaissance. On this level is also the Spanish collection and the large scale nineteenth-century French paintings. On the upper level artists from northern Europe are well represented, along with earlier paintings from the French school.

The imposing Palais du Louvre has been constantly modified since it was raised as a fortified castle at the end of the twelfth century. It was a royal residence in the fourteenth century and reconstructed by the Renaissance King François I in the sixteenth century. The Great Gallery along the Seine was built to join the palace of the Louvre to that of the Tuileries before Louis XIV changed residence for Versailles. The Louvre divides into two sections: the oldest part is the Cour Carrée designed by Pierre Lescot from 1546 to 1556. It encompasses Claude Perrault's magnificent colonnade, which can be seen if one approaches the building from the east. The new Louvre at the western end dates from the nineteenth century. Napoleon took up residence in 1800 and started reconstructing the northern wing and accumulating works of art to boost his reputation as a patron. In 1988 I.M. Pei's glass pyramid was erected over the new entrance to the Louvre, offering the starkest contrast in architectural styles ever witnessed in the constantly changing history of the building.

✪ Venus de Milo

1st century BC

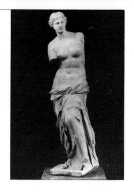

So called because it was found on the Greek island of Melos, the Venus de Milo is the most famous of the Classical statues of the goddess of love. It is likely that it was part of a group which included Cupid, towards whom Venus was probably stretching her arms. It is generally believed that this statue, which was discovered in 1820, was made in the first century BC in imitation of a fourth-century original. It shows the qualities of the best Athenian sculptures which were copied by the Romans, revived in the Renaissance and which became exemplars right up to the challenge of modernism in this century. The figure is anatomically correct, relaxed, idealized and graceful. Muscles, bone and skin texture are suggested on the polished surface of the white marble giving the impression of living form.

Winged Victory of Samothrace

C. 190 BC

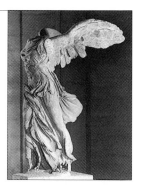

'A roaring motor car, which runs like a machine-gun, is more beautiful than the *Winged Victory of Samothrace*.' wrote the Italian poet Marinetti in his *Manifesto on Italian Futurism* in 1911. The bombast of his exhortations to flood the museums and pull down the Louvre in this brave new world of 'new beauty' shows how the museum and this work assumed a position of artistic pre-eminence in the traditional aesthetic hierarchy. This headless figure, like the Venus de Milo, is one of the universally renowned Classical statues. Discovered in 1863 on the Aegean island of Samothrace, it commemorates a victorious sea battle. This winged figure of Victory stands on the prow of a ship, defying the wind which blows the fabric of her tunic to reveal the fine modelling of the body beneath.

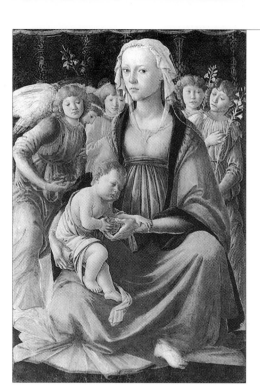

During the last twenty years of the fifteenth century Botticelli (1444/5–1510) ran a large workshop producing devout and pious Madonnas for a public avid for such imagery. His oeuvre also included some of the loveliest pagan mythologies of the Renaissance including *The Birth of Venus* and *Primavera* (both in the Uffizi, Florence). At the entrance to the Italian galleries are two frescoes by Botticelli brought to the Louvre in 1882 from the Villa Lemmi on the outskirts of Florence. These combine Classical mythology with the nuptual celebrations of two noble Florentine families. Botticelli's last years are obscure, and it seems probable that he fell under the thrall of Savonarola, the blood and thunder itinerant priest from Ferrara, whose anti-materialistic rantings affected the Florentine populace in the last decade of the fifteenth century when Florence became a theocracy under his sway.

Little is known of Botticelli after 1500, and he dwindled into obscurity until his resurrection in the last century by critics like Walter Pater, who saw in his melancholy Madonnas a mystery and grace which struck a chord in Victorian sensibility. Botticelli is now seen by many as the greatest of the Florentine Renaissance artists. This tondo is a variant of the *Madonna of the Magnificat* in the Uffizi, and shows the Virgin and Child with angels surmounted by a crown and the rays of the Holy Spirit. The unusual round window behind them enhances the circular composition and the unity of the group.

✪ Marriage at Cana

1562–3

Veronese (Paolo Caliari)

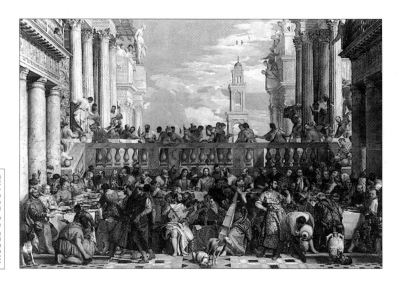

Veronese (1528–88), as his name suggests, was born in Verona. He worked in Venice from the mid-sixteenth century, creating large ceiling paintings in the Doge's Palace. His biblical and historical tableaux are filled with light, colour and sumptuously attired fair-haired females and courtiers. His work is always magnificent and luxurious whether it be biblical or historical, and this led to his being hauled up in front of the Inquisition on a charge of impropriety.

This vast, action-packed painting took Veronese sixteen months to execute. It shows a feast scene where Christ performs his first miracle by turning the water into wine. The scene resembles a large theatrical setting with Christ centre stage, flanked by the Virgin and apostles. The newly-weds are on the left, the clergy on the right. Veronese's lack of religious zeal is emphasized here not simply by his focus on the earthly pleasures of life, but in the contrast of the bleak-faced Christ and Virgin and the merry-making around them. The brilliance and zest of this visual *tour-de-force* is given a final humorous touch by the fact that at the front of the canvas, in splendid Venetian dress, is a small group of the artist's close friends as part of a musical ensemble: Titian, his great Venetian master, is dressed in red and plays double bass; Tintoretto in blue plays a violin; Bassano in a felt hat plays a cornet; and Veronese himself in yellow hose and draped in a costume of white damask plays the viola.

1510

Giorgione (Giorgio Barbarelli) and Titian (Tiziano Vecellio)

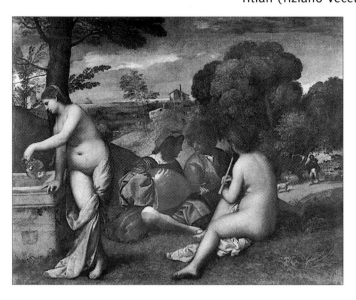

Attributed to both Giorgione (1477/8–1510) and Titian (*c.* 1485–1576), this painting was probably completed by Titian after the death of Giorgione. The known facts about Giorgione's life could be written on the back of a postcard and he left only about six works which we know to be certainly by his hand. They are the first poetic landscapes in art, a genre which the French painter Watteau was to develop two centuries later. Giorgione was the first Venetian artist to produce small oil paintings for private patrons and not for churches. It is entirely probable that these works were suggested by the patron himself, and their meaning is intensely private and impossible to decipher now with any degree of certainty.

This painting shows an idyllic pastorale where, in a glade, both shaded and sunlit, naked women unselfconsciously dip into water or join courtiers in their music making. In the background a shepherd tends his sheep, and beyond the trees distant villas can be glimpsed at the water's edge. The clothes of the central figure are not those of an arcadian shepherd, but contemporary Venetian costume. It would seem then that the other figures also belong to the present day. Without an antique source this painting is harder to interpret. It becomes an image of fantasy, nostalgia and longing. This painting was of immense influence to artists of the last two centuries. Manet was exploring this theme in his *Déjeuner sur l'herbe*, (page 93), and Picasso developed Manet's iconoclastic work in a series of paintings made in the 1960s.

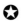
c. 1504

Leonardo da Vinci

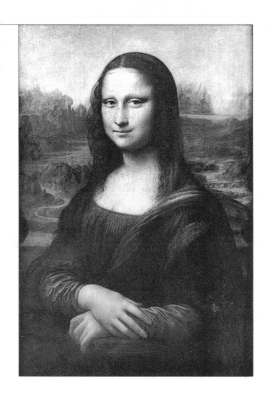

The most famous picture in the world is in the Louvre behind glass and a solid wall of snap-happy observers. So famous is it that it is hard to view it with fresh eyes. What must be remembered when looking at this painting is how it looked to those who first saw it in 1502. Nothing painted before this time touches it for making us believe that the artist had seen and painted a real person who actually looks alive. Contemporary viewers marvelled at the way Leonardo (1452–1519) captured the ambiguity of human expression. Was she smiling or mocking? Leonardo, the arch-empiricist who believed nothing except what experience had shown him to be true, experimented endlessly in art and science, observing, deducing and transcribing. His experimentation with media and methods transformed painting; portraits before this time look harsh. Leonardo noticed that the expressive parts of the face – the corners of the eyes and the mouth – were more life-like if the edges were indistinct. He created a gradual blending of light and shadow to achieve a life-like quality unseen in painting up to this point. The *sfumato* or smoked effect – the blurred quality and soft shadows – give this portrait an elusiveness which deeply impressed sixteenth-century viewers. Careful scrutiny reveals that the two halves of the background are not continuous. The left side is lower than the right and gives a subtle difference to the two sides of the face, increasing the psychological refinement of this work.

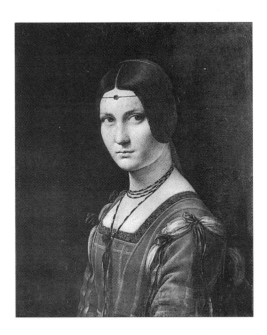

Unlike the *Mona Lisa*, which has a deliciously soft landscape background, *La Belle Ferronnière* is set against an unforgiving black backdrop which intensifies the solemn, thoughtful and private character of Leonardo's sitter. Her powerful face and intense eyes, at odds with the youthful softness and fullness of the skin make this an uncannily life-like and natural portrait. She has no bright jewellery and there are no devices to explain or enhance her status. The painting relies solely on the strength of characterization and execution.

There has been a long running debate as to her identity. *Ferronnière* was the sixteenth-century word for the ribbon ladies tied around their foreheads to keep their hair in place that one can see here, but it was also the name of a mistress of François I. She was always thought to be a duchess of Mantua but an exact identification has proven elusive. Difficulties have arisen in the scientific examination of portraits by Leonardo (1452–1539), as they are on different woods – this one is on oak panel, the *Mona Lisa* on poplar – and there have been many restorations and repaintings which in this picture have altered the hair line, which was originally drawn back behind the ear. Contemporary sources say Leonardo sometimes sat all day contemplating his work without lifting a brush and this thoughtfulness is evident here.

1819

Théodore Géricault

Géricault (1791–1824) described artistic genius as 'the fire of a volcano which must and will burst forth, because the truly creative artist is constrained by a law of his being to shine, illuminate and amaze the world.' He voiced the Romantic spirit, which in France expressed itself not only in the content of a picture but even more in the actual forms on the canvas. Characterized by swirling energetic shapes with aggressive diagonals, and an out-flowing of emotion expressed sensually through paint, this picture opposes all the considered balances of Neoclassicism.

Through this subject Géricault could give vent to his passionate liberal political views in a medium which displayed his virtuosity as a painter. The *Medusa* was a French frigate wrecked en route to Senegal with loss of nearly all lives. Political scandal erupted when it was known that the officers who survived in a lifeboat had deliberately set the raft they were towing adrift. This action echoed for many the government's irresponsibility in letting affairs of state go adrift. The painting is also an allegory of the Romantic soul tossed on a turbulent sea. Whereas Classicism purifies form, Romanticism intensifies it, and in spite of the hopelessness and despair of the drowning, abandoned mariners, the actual thrust of the composition surges vigorously up and forward to the future and the sail is filled with a positive breeze. Géricault, so Byronic in temperament, died young at thirty-three from injuries sustained while riding an unruly horse – the symbol of his chosen creed.

Madame Récamier was a flawless young beauty who married a banker thirty years her senior on leaving her convent. Her looks caused armies of men to fall in love with her, but she preserved her virginity into middle age, emphasizing her purity by the simplicity of her dress and coiffure. Chateaubriand described her as being as seductive as Venus and as inspirational as a muse. Chateaubriand's allusion to the Roman goddess of love is in keeping with the revival of the antique, for this portrait encapsulates the cool Neoclassicism of David's art. Arrayed in a simple white Empire-line shift and barefoot, the beautiful young woman is placed on a divan (to which her name was later to be given) in a dark empty room where the only other piece of furniture is a lamp painted by David's pupil Ingres, who was so struck by this pose he adopted it in his *Grande Odalisque*, also in the Louvre (page 77). The portrait was refused and Madame Récamier immediately commissioned another from Gérard, now in the Musée Carnavalet, which is a warmer work showing her much more seductive and glowing.

David (1748–1825) was a political animal who became a Deputy during the Revolution and voted for the death of Louis XVI. He was imprisoned after Robespierre's fall, and released due to the petitions of his pupils and wife. He painted several memorable portraits of Napoleon as well as dramatic and chilling scenes of Roman history.

Liberty Leading the People

1830

Eugène Delacroix

The Louvre's gallery of giant French nineteenth-century paintings contains four of Delacroix's most famous works. With Géricault, Delacroix (1798–1863) was the great French painter of the Romantic age and is always contrasted with the Classicist Ingres. He defined his credo in his diary: 'If one means by my Romanticism the free expression of my personal impressions, my remoteness from the groups which are inevitably fossilized into schools, and my repugnance to academic formulae, then I must say I am a Romantic.' He also maintained that the most beautiful works of art were those that 'express the pure imagination of the artist.'

This work was inspired by contemporary events. It fuses allegory and real life in an idealization of the July Revolution of 1830. This work develops the composition Delacroix used in his *Greece Expiring on the Ruins of Missolonghi*, painted three years earlier, which also shows a large allegorical figure at the apex of a triangular pile of dead bodies. The artist shows himself brandishing a gun at the barricade. Delacroix's powerful figure of political liberty brandishing the *tricouleur* in her right hand and a bayonet in her left bears a strong resemblance to the *Venus de Milo* discovered in 1820 and first shown in the Louvre the following year (page 52). Using this Classical figure may also have been a direct challenge to Ingres' *Apotheosis of Homer* (also in the Louvre) which was based on the antique *Victory* (page 52). Delacroix's powerful diagonals and use of strong colour are also in direct opposition to the restrained composition and colour scheme used by Ingres.

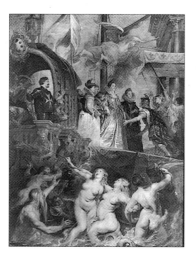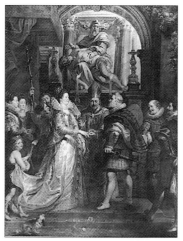

Rubens (1577–1640) enjoyed one of the most successful careers in the history of art. Knighted by Charles I of England and employed by the principal sovereigns of Europe, this exceptionally industrious diplomat and painter from Antwerp enjoyed a long and happy life, creating a huge output and leaving a lasting influence on subsequent painters.

In the 1620s Rubens received his major commission. The widow of Henri IV of France, Marie de Médicis, wished to decorate the gallery of the Luxembourg Palace which she had designed in emulation of the palaces of her native Florence. To this end Rubens was required to supply twenty-one works intended to celebrate her person and to commemorate her reign. Now hanging in their own room in the Louvre they are a monument to Rubens's supreme achievement of creating a grandiose Baroque cycle from the unpromising starting point of glorifying a queen who was neither beautiful nor interesting. He overcame this problem by creating an allegory of the simple facts of her life cleverly integrated with Classical allegory, thus the first painting shows the Fates spinning the thread of life of the unborn Queen under the watchful eye of Jupiter and Juno. This particular device meant that Rubens could ennoble the Queen's character without actually painting her likeness. It also meant that he could fill his canvases with opulently dressed seventeenth-century courtiers and the naked gods of Olympus.

Gabrielle d'Estrées and her Sister

1594

School of Fontainebleau

Painted by an anonymous artist of the School of Fontainebleau, this double portrait showing Gabrielle d'Estrées and her sister in a bath is an extraordinary and memorable work. The artificiality of the elaborate hair, the stiffness of pose and above all the one sister pinching the other's nipple all reflect the influence of Florentine Mannerism. This may be a picture of symbols and clues in which the key to unlock the mystery is lost and we have only supposition to go on.

The composition of this painting is very like Clouet's *Lady in her Bath* (National Gallery of Art, Washington) painted two decades earlier, and may help in the understanding of this work. In Clouet's painting an elaborately coiffed woman is shown naked from the waist up in a draped bath identical to that shown here. Instead of a sister, a smiling wet nurse on the left suckles a swaddled child, while in the backgound a scene of domestic activity is depicted. Here, the suggestive gesture of the Duchesse de Villars may simply refer to her sister's pregnancy, a supposition reinforced by the background which shows a nurse preparing a layette. The cool, elegant eroticism of this work reflects the courtly *fin de siècle* style of the Fontainebleau school. The influence of Leonardo can be seen in the lower part of the painting: the sisters' right hands are painted to imitate those of the *Mona Lisa* (page 56).

In a darkened grotto behind which lies a sunlit bay reclines a graceful nude of supreme elegance and loveliness. Little is known of the artist Jean Cousin (*c.* 1490–1560/61) who made this work. In 1538 he moved from Sens to Paris, where he established himself both as a painter and a designer of stained glass. The influence of the Italian school can be seen in the Leonardesque contrast of shadow and light, in the profile which resembles those of the Florentine Mannerist, Rosso Fiorentino, who had left Florence to work for François I, and in the body which bears similarities to the nudes of Cellini, who was also working for the King at this time. Further Mannerist influence can be seen in the combination of the naturalism of the nude and the sophistication of her pose, her bejewelled headwear, and her elegantly draped limbs.

The deliberate artificiality of a title hanging within the actual painting informs us that this nude is the *femme fatale* of both the biblical and the Classical world, and as such is to be viewed as a temptress and destroyer. The hand of her beautifully posed left arm delicately touches an ornate urn, alluding perhaps to the container of secrets Pandora is forbidden to unlock. Entwined like a slim bracelet around her arm a serpent symbolizes Temptation and Fall. Beneath her right arm, in contrast to her youthful beauty, is a skull, a *memento mori* and symbol of the destruction wrought by Eve's transgression.

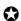

⭐ The Madonna with Chancellor Rolin

1452

Jan van Eyck

Jan van Eyck (*c.* 1390–1441) is one of the most important figures in the history of European painting. He was instrumental in the early development of oil painting, and the jewel-like brilliance and the clarity of detail shown here are the result of a meticulous technique in which the oil paint is applied in very dilute form, translucent layer upon translucent layer.

This painting was transferred to the Louvre in 1800 from the collegiate church of Notre Dame at Autun, where Nicholas Rolin, the Chancellor of Burgundy, was buried. Rolin appears in the painting kneeling before the Virgin Mary, the Queen of Heaven. The Christ Child holds a crystal orb, which represents his kingship. The donor and the holy figures share the same semi-enclosed space in front of a classical portico which gives on to an elaborate landscape beyond, a parapet on which two figures and a peacock can be seen. The geometrically figured tiles contribute to an illusion of space and depth, taking the eye beyond the portico into the landscape. Tiny figures can be seen crossing the bridge into the city, which is shown on the right. This city is painted with such astonishing detail that various attempts have been made to identify it: critics have suggested locations as varied as Maastricht, Lyons, Utrecht, Liège, Prague, London and Brussels. The fact that none of these attempts at identification has been conclusive perhaps testifies to the extraordinary particularity of Van Eyck's imagination.

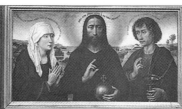

MUSÉE DU LOUVRE

Rogier van der Weyden (1399/1400–1464) is one of the great figures of fifth-century Flemish painting, and the depth of religious feeling expressed in this triptych is typical of his work as a whole. The painting consists of three panels: the central one shows Christ between the Virgin and St. John the Evangelist, the left and right panels show St. John the Baptist and St. Mary Magdalene. The holy figures are associated with inscriptions from the Bible. The reverse of the panels link the painting with Jehan Braque de Tournai and the wife he married in 1451, Catherine de Brabant: the reverse of the left panel contains the Braque arms, the right the female shield of Braque and Brabant. The left panel contains a skull on a piece of brick, and an exhortation to the proud and avaricious onlooker to consider its meaning: 'My body which was once beautiful now is meat for worms'. The right panel contains an inscription from Ecclesiastes, stressing the miseries of this life and the fear of death, contained within a cross. The circumstances of the commission are unknown, but given the absence of portraits of donor figures and the nature of the inscriptions on the reverse of the side panels, it is likely that the work was commissioned as a memorial portrait by his widow after Jehan's death in 1452.

The Ship of Fools

c. 1490–1550

Hieronymus
Bosch

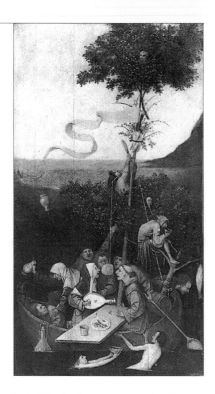

An exact contemporary of Leonardo da Vinci, who represents the flowering of the Italian Renaissance, Bosch (c. 1450–1516) embodies the waning of the Middle Ages in the North. Little is known of this artist who spent his life in 's-Hertogenbosch in north Brabant, now part of Holland, but it appears that his art was widely admired outside his native city. We know also that Bosch was a member of a religious community and that his faith was fervent and orthodox. The Catholic zealot Philip II of Spain was a great collector of his work, and earlier in the twentieth century Bosch's extraordinary fantasies made him especially attractive to the Surrealists. His appeal lies in his close observation of everyday life, in his vivid landscape studies, but principally in his extraordinary imagination.

This painting is a mature work which was possibly inspired by Sebastian Brant's poem of the same name. Satire of an anti-clerical nature is clearly intended although the precise meaning is unclear. The central figures in this madcap boating party are a nun and a monk singing with a group of revellers at a loaf of bread hanging between them. The boat is adrift, its mast, a sprouting tree, bears a flag displaying the Turkish crescent moon above a trussed pig. The symbolism of the surrounding figures such as the fool on the branch, the figures in the water, or the couple to the left of the boat, is obscure.

Goethe admired this self-portrait of 1493 and held Dürer (1471–1528) up as a model, saying 'let the world be for you as Albrecht Dürer saw it – with vitality and virility, his inner strength and resolve.' Dürer was only twenty-two when he painted this, one of his many self-portraits. It is one of the first self-portraits in history. Prior to this artists had tended to include their images modestly in the context of large compositions. The self-portrait reflects the idea of individual moral responsibility and self-questioning which came with the spread of Protestantism. Dürer wrote that the Papacy with its burden of human laws was in opposition to the freedom promised by Christ. He described Martin Luther as 'that great Christian man, thanks to whom I have freed myself from great anguish.'

This self-portrait was probably executed as a gift to his betrothed. It shows him holding a thistle or eryngium – a symbol of marital fidelity and of Christ's passion. The plant here is offered as a token as well as a record of the young artist. Larger variants of the miniature like this portrait served as keepsakes, and were intended to be kept on desks and chimneypieces. Proud of his good looks, Dürer shows himself in three-quarter view, in a fine jacket and undershirt. The difficulties of painting from a mirror show in the slight rigidity of expression in comparison with the fluidity of treatment in his later portraits.

1523

Hans Holbein
the Younger

This portrait of the greatest intellectual of the Renaissance was painted by one of the finest portrait painters of the North, Hans Holbein the Younger (1497–1543). He was born in Augsburg, but was working in Basle when he first met the humanist scholar from Rotterdam, whom he painted three times. It was Erasmus who gave Holbein letters of introduction to Sir Thomas More when he travelled via Antwerp to England. He was to transform the tradition of English painting by introducing an entirely novel degree of realism. Famous for his renderings of Henry VIII and his court and for his portraits of Sir Thomas More and his family, Holbein, like Erasmus, moved from one European city to another. Both men settled for a time in England, which in the fifteenth century was considered an unruly island on the edge of the civilized world. Erasmus was for a decade the most famous man in Europe. His scholarship was of such eminence that he is described as the last man to know everything before the expansion of knowledge made such a claim impossible. Witty and satirical, Erasmus is celebrated principally as a religious reformer, though gradually his ideas incurred disfavour with both Protestant and Catholic wings. Holbein shows him here in profile, an image which recalls those of the apostles. This association is further reinforced as Erasmus is writing the first words of his own commentary on the Gospel of St. Mark, whose lion symbol is repeated on the wall hanging. The naturalism in this portrait is typical of Holbein at his best.

The Dutch painter Vermeer (1632–75) produced only a small corpus of work, most of it showing a single figure or a small group in a calm, peaceful interior. This picture is one of the rare examples in which the light falls from the right, and it shows the artist at his finest, transforming a simple task into an image of timeless serenity. The sitter here is absorbed in her lacemaking. This was a major applied art form in the seventeenth century, and this painting does not simply show a slice of domestic realism but a woman at work and, as emblem books of the day reveal, a symbol of the virtue of domesticity.

Delft where Vermeer lived and worked was a great centre of optics. Leeuwenhoeck, the father of microbiology, invented the microscope here, and was, incidentally, the executor of Vermeer's bankrupt estate after the artist's death. The actual mechanics of seeing are important in this work, and it is likely that Vermeer used the optical device of a camera obscura to achieve the intensity of focus. The detailing of the threadwork in contrast to the generalized painting of the face backs up this interpretation because this is the type of distortion the device produces.

Bathsheba in her Bath

1654

Rembrandt van Rijn

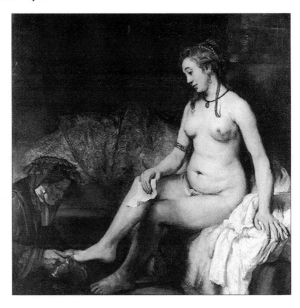

Rembrandt (1606–69) reinterpreted sacred history and mythology in the light of human experience. Although his is an emotional and truly human response, it is based on belief and truth as revealed in the Scriptures. This sets him apart from many of his greatest contemporaries who sought the truth via intellectual means. Rembrandt chose to express humanity in all its vulnerablity. He worked through darkness to light and his technical language, expressed in the subtlety and depth of his tones, was often symbolic or allegorical. Here he reveals the tender warmth of Bathsheba's personality which caused King David to compromise his faith and even to send her husband into battle in the front line in order to be killed, an episode which later inspired the beautiful fifty-first Psalm in which like Rembrandt himself, David confesses his human frailty.

Rembrandt seems to convey the personality of all women in a non-idealized presentation of universal femininity. Soft, vulnerable and patient, Bathsheba waits for her feet to be washed while the letter from David lies in her hand. There is a profound feeling of forgiveness and an acceptance of erring as a fact of human nature. Rembrandt was born in Leyden but it was in Amsterdam that he was introduced to the rhetoric of the Baroque and specifically its dramatic use of light, through the Caravaggio school in Utrecht. His taste for rich Oriental dress and delight in dressing up reveals an unexpectedly extrovert characteristic in his otherwise sombre nature.

MUSÉE DU LOUVRE

Forgotten for two-and-a-half centuries, the work of Georges de La Tour (1593–1652) has been rediscovered only comparatively recently, and now occupies an important place in the history of French seventeenth-century painting. Like Vermeer, the artist's output was small; there are only about forty known works, although some of the finest are here in the Louvre. The facts of his life are still obscure, but what we do know suggests he was violent, lascivious, unpopular, and quite at odds with the deeply moving humanity reflected in his work. Apart from a sojourn in Italy and a trip to Paris in 1689 to receive the title Painter Ordinary to the King from Louis XIII, he seems to have hardly left his native Lorraine.

His dramatically candle-lit scenes derive directly from Caravaggio, whose work he may have seen in Rome, or indirectly through the Dutch Caravaggists, who also employed similar atmospheric effects. The use of artificial light in a darkened interior is typical of the paintings of the artist's mature years. This picture shows a cardsharp, a servant and a courtesan planning to trick an ingenuous youth. It is a work of psychological interaction depicting a game of glances and hand gestures. A look exchanged between the courtesan and servant, and the glance that the cardsharp gives the viewer as he shows his Ace of Diamonds, directly involves us in the complicity, creating a disquieting atmosphere of tension.

Ex-Voto

1662

Philippe de Champaigne

Philippe de Champaigne (1602–74) was born in Brussels in 1602, but spent the greater part of his life working in Paris. He was a man of a deeply religious temperament who, like his contemporary Pascal, was profoundly influenced by the sincerity and austerity of Jansenist Christianity, centred around the Parisian convent of Port-Royal, where Champaigne's daughter was a nun. This painting is both a thanksgiving for, and a depiction of, a miracle. The artist's daughter was struck down by a progressive paralysis in 1660, and by 1661 was completely unable to walk. The abbess of the convent prayed for her recovery, and miraculously she was completely healed. The Latin inscription on the left of the painting tells us that Christ is the only doctor of the soul and body, and that Sister Catherine Susanna de Champaigne was gravely ill for fourteen months before her recovery. This picture reflects the austerity of Jansenism: the miraculous intervention is shown in a very controlled manner, by the ray of light falling between the two figures. The painting is otherwise very restrained in its tonal values, relieved only by the red of the crosses on the nuns' habits.

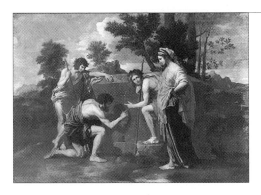

Et in Arcadia Ego (The Arcadian Shepherds)

c. 1638

Nicolas Poussin

Poussin (1594–1665) was born into a peasant family in Normandy, but spent most of his career as a painter in Rome. He is one of the very greatest French artists, and excelled in compositions based on Classical subjects. The Latin inscription on the tomb which gives this painting its title roughly translates as 'Even in Arcadia, I, Death, am Present', serving to remind the onlooker of the omnipresence of death without employing traditional Christian imagery. The modelling, posture and drapery of the figures show Poussin's admiration for Greek and Roman sculpture, which had been the object of his constant study. In contrast with an earlier version of the subject, the figures do not react with any urgency: there is an atmosphere of stoical calm and dignified acceptance which informs the whole composition.

MUSÉE DU LOUVRE

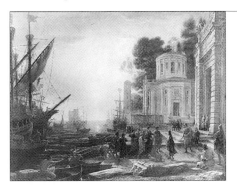

Embarkation of Cleopatra for Tarsus

1642–3

Claude Lorrain
(Claude Gellée)

Like Poussin, Claude (1600–82) spent his working life in Rome, where he enjoyed a highly successful career as a painter of idealized landscapes. Because landscape painting was seen as an inferior genre to history painting until the nineteenth century, Claude's paintings incorporate biblical or Classical subject matter, although it is evident that his keenest concern was for poetic landscape. His compositions are framed by an asymmetrical arrangement of trees and a middle distance featuring a bridge or lake leading to a background of blue mountains. His seascapes, of which this is a good example, exchange trees for Classical buildings and the reflection of the setting or the rising sun on the water.

MUSÉE DU LOUVRE

1721

Antoine Watteau

Watteau (1684–1721) was a strikingly original artist of a highly independent cast of mind. In an age when most work was carried out to a specific commission, much of his best work was painted simply to please himself, as is shown by the singularity of the subject matter. Instead of choosing to represent subjects of a religious or Classical nature, Watteau was attracted to clowns, charlatans, gypsies and street scenes, as well as lovers in a landscape. The artist seems to have regarded these figures as kindred spirits, and his paintings show a keen psychological interest as well as a delight in their very theatricality. A late work, *Gilles* – a portrait of an Italian actor – embodies all that is striking and unusual in his work. The large scale of the picture is surprising, and the onlooker is drawn to the curiously static centrally placed figure, dressed in theatrical costume, his arms and hands hanging symmetrically in front of him. His facial expression seems to combine both mirth and sadness, perhaps suggesting the transitory nature of pleasure. Shortly after Watteau made this painting he died of tuberculosis as did the patron and model of the work.

The painting contains much that is typical of Watteau's work at its best. The reclining figures in the delectable landscape seem to have been taken direct from nature. This is however illusory: many of the figures in Watteau's landscapes come from the large bound volumes in which he kept many hundreds of extraordinarily detailed drawings.

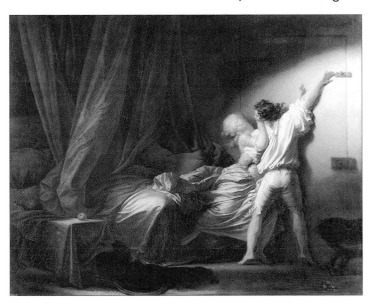

MUSÉE DU LOUVRE

Fragonard (1732–1806) is best known today for small-scale narrative works charged with a certain erotic tension, of which this is a prime example. His landscapes are among the most successful of the eighteenth century, and he was greatly in demand as a portraitist. This painting was a companion piece to a religious *Adoration* and marks a turning point in Fragonard's art; the use of pronounced chiaroscuro and the dramatic diagonals are not typical of his previous work. Its vital, daring and dramatic treatment of form were noted by contemporaries, while its racy subject matter made it the source of many engravings.

A contemporary catalogue describes the picture in the following terms: 'an interior with a young man and a young woman: the former is bolting the door, and the latter attempting to stop him; the scene takes place next to a bed whose disorder tells the rest of the story sufficiently clearly.' The light falling on to the yellow-haired woman highlights the balletic movement of her attempt to resist and her head is distorted stylistically to exaggerate her struggle. It would seem that the young woman is not that unwilling: although she stays the man's hand, her gesture could also be read as a caress. The halo of light on the couple gives a glow to the yellow-blue colour harmonies, which are contrasted with the darkness of the red-green of the curtained bed. The fallen flowers on the floor and the apple on the table symbolize the fallen state of the young woman and underline the subtitle of this work: *The Useless Resistance*.

Young Draughtsman Sharpening his Pen

1737

Jean-Baptiste-Siméon Chardin

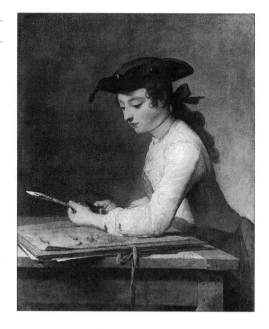

Chardin's work possesses the same tranquility and restraint as Vermeer's. Like the Dutch artist, Chardin (1699–1779) was able to transform the everyday into an image of exceptional beauty through a combination of skilfully balanced composition and closely observed detail, handled with the most delicate treatment of colour. Chardin was not a painter of large allegorical subjects but of brooms, pots, pans and earthenware vessels and their users, and his early works are still lifes. His later genre pictures depict quiet domestic scenes where industry, order and duty are tacitly condoned. It would probably have surprised Chardin's contemporaries to discover the great esteem in which he is now held.

This painting is one of two identical works, signed and dated the same year. They are among the artist's best documented paintings and we can trace the history of this picture from its sale to an art lover based in London up to its acquisition by the Louvre in 1968. This work is one of Chardin's most perfect; its subject was described by the Goncourt brothers who knew it from engravings as 'tall and slender, elegant, with his three-cornered hat firmly planted on his head, the flow of a large wig rippling down his back, indolently sharpening his pencil.' Chardin is the great master of quiet *gravitas*, the portrayer of dreamy concentration, the small gesture, and the simple action.

MUSÉE DU LOUVRE

Ingres (1780–1867)was the arch-exponent of the Classical tradition in painting in the first half of the nineteenth century and the chief opponent of Romantics such as Delacroix and Géricault. His main works were portraits and nudes. As a pupil of David he was inspired by works of antiquity, despised messy improvisation and insisted on precision and clarity. His visit to Rome in 1806 led to an eighteen-year sojourn there, during which time he became the Director of the French Academy. He expressed himself in exquisitely rendered line: the stress on line was as essential to the Classicists as colour was to the Romantics. The inspired simplicity and poise of many of Ingres' figures echo those of the ancient Greeks, and to this he added an exotic Orientalism in his turbanned headdresses and subjects like the *Turkish Bath* (page 10).

The *Grande Odalisque* shows Ingres at his best. The painting is one of the most beautiful studies of the female nude ever executed and is frequently reproduced. The simplicity of form, the clarity of execution and the colour are exquisite. The setting shows a seraglio, or harem, which was a popular motif at the time since, like mythology, it allowed artists to portray sensual and erotic nudes which did not contravene the accepted proprieties of the day. It was Ingres' influence which brought about the change from male to female life models in drawing classes of art academies.

Souvenir de Mortefontaine

1864

Jean-Baptiste-Camille Corot

'There you have the greatest genius of the century, the greatest land-scape artist who ever lived. He was called a poet. What a misnomer! He was a naturalist. I have studied ceaselessly without ever being able to approach his art…I wanted to emulate him.' This was Renoir's homage to Corot (1796–1875), made the year before he died. Monet too, having criticized Corot for not putting enough paint on his canvases, came to be 'more and more convinced that Corot was a great painter.' Monet emulated Corot's recommended procedure for making paintings – rising before dawn to capture the particular effects of light on water from a flat-bottomed boat. Corot said of his own work: 'To enter fully into one of my landscapes, one must have the patience to allow the mists to clear; one only penetrates it gradually, and when one has, one should enjoy it there.'

A classically trained artist he built his work up tonally in the academic manner in contradistinction to the stronger palette employed by the Impressionists. He told Pissarro, 'You see green, I see grey and blond.' Corot was a major influence on the Impressionists both in terms of subject matter and technique. Like them, he portrayed the semi-rural suburbs to the west of Paris – Mortefontaine was actually a large park to the north of the capital city. The figures in the picture are a mother and her two children gathering brushwood from a tree.

The highlight of this museum is the collection of Impressionist paintings bequeathed by Monet's younger son Michel. It includes Monet's *Impression, Sunrise* (1872), after which Impressionism was named (page 80). The painting was stolen in 1985 along with several others, and returned to the museum in 1991. The Michel Monet bequest comprised sixty-five works by his father. These range from quintessentially Impressionist canvases of the 1870s such as *Camille Monet and her Cousin on the Beach at Trouville*, and *Pont de l'Europe – Gare Saint-Lazare*, to the late, often very sketchy, abstract exercises in colour made during the first quarter of this century. These flower pieces, most of them executed at Monet's garden at Giverny, are housed in a lower gallery and complement the large series of waterlily paintings displayed in the Musée de l'Orangerie (page 86).

Michel Monet also bequeathed to the museum his father's personal collection of Impressionist paintings. These include Caillebotte's lovely *Rain in Paris, at the Crossroads of rues de Turin and Moscou* (1877); Renoir's portrait of Monet (1872) and works by Pissarro, Sisley and Morisot. The museum is housed in the nineteenth-century residence of the collector and art historian Paul Marmottan, whose fine collection of medieval, Flemish, Renaissance and Napoleonic art he left to the Institut de France in 1932. At the end of 1987 a further bequest expanded the collection with a donation which included Gauguin's *Bowl of Tahitian Flowers*, Corot's *The Lake at Ville d'Avray seen through Trees*; Monet's *Walking near Argenteuil*, and Sisley's *The Canal du Loing in Spring*.

Address
2 rue Louis Boilly Paris 16e
 42 24 07 02

Map reference
⑱

How to get there
Metro: La Muette
Bus: 22, 32, 52, PC.

Opening times
Tue to Sun 10–5.30 (last admission 5)
Closed Mon.

Entrance fee
35F, 15F for students, groups and Friends of the Louvre.

1872

Claude Monet

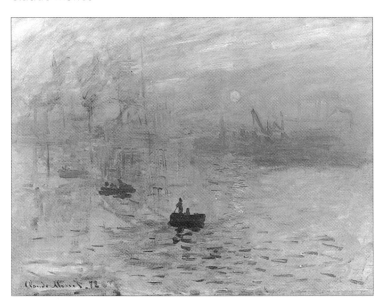

This painting, which gave its name to Impressionism, was exhibited in 1874 in the Nadar studios on the Boulevard des Capucines. Here the critic Louis Leroy saw it, and wrote in *Le Charivari* 'Impression, I was sure of it. I also thought, as I'm impressed, there must have been an impression in it', adding 'Wallpaper in its first stages is more finished than this seascape.'

Its lack of finish and crudity of colour and execution were daring innovations in the 1870s. Monet (1840–1926) was not to repeat this audacity until his waterlily series three decades later. However, *Impression – Sunrise* has links with the past as well as the future. It has its precursors: other artists before Monet had been interested in rendering solely their impressions of reflected light and colour. Notable among these was Turner, whose work Monet had seen in London in 1870. Monet's remark to a friend that he felt as though he were dying when the sun went down echoes Turner's dying words 'the sun is God'. Both men, in their observations of light on water created pictures which closely prefigure abstraction. The canvas visible through the paint, the evidence of brushwork and the thickness of the medium are all features which modern abstractionists have homed in on since they stress the supremacy of the execution of the work over the rendering of an object as the artist's principal aim.

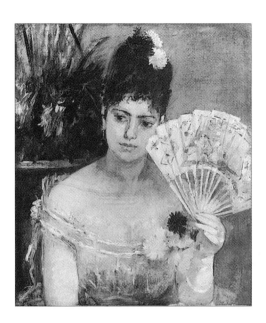

'My ambition' the artist jotted down in her notebook, 'is to record something as it passes, oh, something, the smallest of things! … an expression, a smile, a flower, a fruit, a branch of a tree.' Works by Morisot (1841–95) are full of a delicacy and sensibility unusual in Impressionist pictures. She is the Henry James of painting, revealing a subtlety and insight into underplayed emotion. While her technique resembles that of Monet, her opaque and highly sensitive fragments of passing time have more in common with the late work of Manet for whom she frequently posed, whose work she greatly admired, and whose brother Eugène she married six months before this canvas was painted.

In this masterpiece of discretion the artist has caught a fleeting expression of a young woman in evening dress seated at a soirée, her fan held to her face as she glances out of the painting to her right. The event is of no great moment and her expression and attitude simply reflect grace and loveliness. Comparing this work with Manet's *Balcony* in the Musée d'Orsay, where Morisot posed for one of the seated models, it is tempting to see here the beauty and characteristics of the artist herself. It is suffused with something of the sentiments recorded in her notebooks, 'an impression close to the joys and sorrows known only to the initiated.'

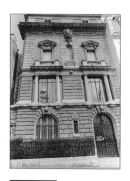

Address
14 rue de la Rochefoucauld,
Paris 9e
 48 74 38 50

Map reference
⑲

How to get there
Metro: Trinité, St-Georges

Opening times
Thur to Mon 10–12.45 and
2–5.15; Wed 11–5.15.
Closed Tue.

Entrance fee
17F, 11F reductions and on
Sunday.

'The discovery of the Gustave Moreau Museum when I was sixteen, affected forever my aesthetic sensibility,' wrote the Surrealist André Breton, who confessed he had always dreamed of getting in at night to see the paintings by lamplight. 'It was there that I had the revelation of what beauty and love were all about – in front of certain faces, certain poses of women. This small museum, which houses a stupendous collection of the arch Symbolist's *fin-de-siècle* paintings, opened in 1903, five years after the artist's death. Moreau, affected by the influence of the English Pre-Raphaelitites, created jewel-encrusted fantasies of a mythological world or the sombre splendour of Byzantium. The poetic melancholy of his paintings, like those of Puvis de Chavannes and Odilon Redon, made Moreau's work exceptionally attractive to the Decadents. The *femme fatale* is a constant subject: virgin, sphinx, vampire, harpy and siren, she appears as *The Lady with the Unicorn, Salomé, Helen, Delila,* a *Chimera, Semele, Eve,* or *Leda.*

J-K Huysmans writing in *L'Art Moderne* in 1888 encapsulated Moreau's attraction for a generation of Symbolists: 'Gustave Moreau is unique. He is a mystic, isolated in the heart of Paris in a cell where no noise of contemporary life enters the portals of his cloister. Abandoned to ecstasy, he sees the enchanted visions and bleeding apotheoses of other ages. His paintings do not seem to belong to painting proper…one feels, in front of these paintings, the same sensations as one feels reading a strange and captivating poem, like Baudelaire's *Dream.*'

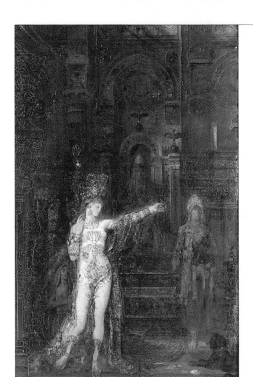

At the Salon of 1876 Moreau (1826–98) exhibited the first of his *Salomé* series, which became his best known paintings. In the dark and splendid halls of King Herod, Salomé dances in jewelled, transparent raiment to gain the head of St. John the Baptist. The writer J.K. Huysmans seized on Moreau's *Salomé* as an image of lust and evil made flesh. In his novel *A Rebours* (Against Nature) the decadent hero Des Esseintes sees in Salomé the embodiment of eroticism: 'She was no longer just a dancing girl who extorts a cry of lust and lechery from an old man by lascivious movements of her loins; who saps morale and breaks the will of a king with the heaving of her breasts, the twitching of her belly, the quivering of her thighs. She had become the symbolic incarnation of undying lust.'

A variation on *Salomé Dancing before Herod*, now in the Hammer Collection in Los Angeles, this work is sometimes incorrectly subtitled *Salomé Tatooed* due to the evidence of designs in Chinese ink on her body. These designs were evidently meant to be traced over in paint as they were in the Los Angeles picture, which was executed with identical under-drawing.

Address

63 rue Monceau, Paris 8e

 45 63 26 32

Map reference

⑳

How to get there

Metro: Villiers, Monceau

Opening times

Wed to Sun 10–12 and 2–5.
Closed Mon and Tue

Entrance fee

15F adults.

Tours

Guided tours available.

The mansion housing this museum was built 1910–14 in the style of the Petit Trianon in Versailles, by Comte Moise de Camondo, a prominent Jewish banker, who was aiming to recreate an aristocratic mansion of the eighteenth century. The interior rooms are elegantly panelled in the manner of a Louis XVI Salon and contain a fine eighteenth-century collection including Savonnerie carpets and Beauvais tapestries. The Aubusson tapestries showing six La Fontaine fables are among the most important of these hangings. There is a splendid Sèvres porcelain Buffon service in which each piece is decorated with a different bird. There are fine pieces of period furniture, and paintings by Guardi, Lancret, Hubert Robert and Horace Vernet.

De Camondo left his collection and house to the nation in memory of his son Nissim, killed in 1917 during World War One. Dying in 1935, the Count was spared the knowledge that his daughter and grandchildren were to die in Auschwitz during World War Two.

At the southwest end of the Tuileries Gardens is the Orangerie, which since 1984 has housed the collection of paintings acquired by Jean Walter and Paul Guillaume, and bequeathed by Domenica, the woman who married them both, on the condition that the collection remain intact. The building is delightful and the collection, while not being of the same standard as that in the Musée d'Orsay, is certainly worth a visit. The donation consists of 144 paintings. The majority are by André Derain; there are also two dozen Renoirs, almost the same number of Soutines, fourteen Cézannes, a dozen works by Picasso and Matisse, and pictures by Henri Rousseau, Utrillo, Modigliani, Marie Laurencin Van Dongen, Sisley and Monet, but the crowning glory of the museum is the two oval rooms displaying Monet's *Waterlily* series. Given to the nation by Monet in 1922 and installed in the Orangerie months after his death in 1927, they dispense with the conventional image of painting, offering no clear composition, simply an experience of light and colour.

Address
Jardin des Tuileries
Place de la Concorde,
Paris 1e
✆ 42 97 48 16

Map reference
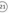

How to get there
Metro: Concorde

Opening times
Wed to Mon 9.45–5.
Closed Tue.

Entrance fee
27F, 18F Sun and for
students and over 60s.
Children under 12 free.

✪ Waterlilies

1916–26

Claude Monet

MUSÉE DE L'ORANGERIE

The *Waterlily* series was painted in Monet's garden at Giverny, to where he had moved in 1883. In the early 1890s he diverted the river Ru through his garden and planted it with waterlilies, enlarging it after 1900. On becoming a widower for the second time in 1911 Monet was distraught. His eyesight was also failing, and when his son died in 1914 he was at a very low ebb. This same year his friend, the politician Clemenceau, persuaded the artist to take up an idea he had been considering since the late 1890s – a lily pond series in a single continuous decorative scheme, running around a room. In 1916 in a vast purpose-built studio Monet (1840–1926) began his succession of huge canvases of water studies, working from memory and from smaller *plein-air* sketches. 'The water-flowers themselves are far from being the whole scene', Monet explained, 'really they are just the accompaniment. The essence of the motif is the mirror of water, whose appearance alters at every moment, thanks to the patches of sky which are reflected in it and which give it light and movement. The passing cloud, the freshening breeze, the light growing dim and then bright again, so many factors, undetectable to the uninitiated eye, transform the colouring and distort the plane of water. One needs to have five or six canvases that one is working on at the same time, and to pass from one to the next and hastily back to the first as soon as the original interrupted effect has returned.'

The Collection

The collection has come principally from late works in the Louvre and the Impressionist paintings in the nearby Jeu de Paume, and includes work from the mid-nineteenth century to the early twentieth, chronologically bridging the Louvre and the Pompidou. Earlier works are well-displayed on the ground floor while the collection of first-rate Impressionist paintings, which most people come to view, are on the upper floor of the museum to benefit from natural overhead light. On this floor are also works by the Symbolists, Nabis and Fauves. At the far end of the building, on the ground floor, is a room dedicated to the Paris Opéra with a model of the building by the architect Garnier, a map of the *quartier* beneath a glass floor, and a segment of Carpeaux's sculpture from the façade. To the left is a display of architecture spanning the second half of the last century, and a view of Paris painted in 1855 from a balloon.

The sides of the building on the second floor contain popular art of the nineteenth century and rooms with furniture and decoration by prominent *fin-de-siècle* designers. The building is vast and much work has been taken out of reserve stock to pad out the displays. To avoid fatigue it is advisable to look first at the paintings on the ground level including works by some Impressionist painters, and then to take the escalators to the upper floor to see the Impressionists and their successors. Works on the second floor can then be seen after a break in the café, along with those missed on the ground floor.

Address

1 rue de Bellechasse,
Paris 7e

✆ 40 49 48 14

Map reference

㉒

How to get there

Metro: Solférino,
Assemblée Nationale
Bus: 24, 63, 68, 69, 73, 83,
84, 94.
RER: Musée d'Orsay

Opening times

Apr–Oct 9–6 Tue to Sun
(open until 9.45 on Thur);
Nov–Mar 10–6 Tue to Sat
(open until 9.45 on Thur):
Sun 9–6.
(Last admissions 45mins
before closing times)
Closed Mon, 1 Jan, 1 May,
25 Dec.

Entrance fee

35F adults, 24F on Sun.
Under 18s free.

MUSÉE D'ORSAY

The Building

Remodelled 1986

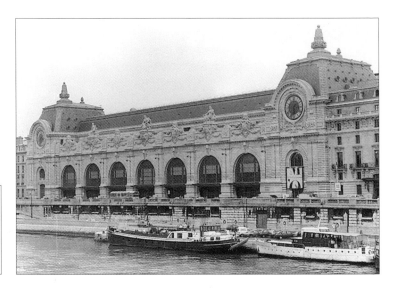

The Musée d'Orsay opened in 1986 as a museum to house work from the second half of the nineteenth century to the beginning of the twentieth, and the building still retains the grandeur and impressiveness of Victor Laloux's great railway terminus in the heart of Paris. The lavish facade of the former Gare d'Orsay was designed to complement the Louvre which stands diagonally opposite across the river. Its short platforms meant that by the late thirties modern trains could no longer use the station, and it became a circus venue for a short period until plans were made to demolish it. Fortunately, Parisians horrified by the demolition of Les Halles, protested, and it was declared an historic monument in 1973. In 1981 the internal alterations began following the designs of the Italian architect Gae Aulenti, who has successfully reworked the interior of the former station to take visitors to various levels without interrupting the flow and space of the original building.

Birth of Venus

1869

Alexandre Cabanel

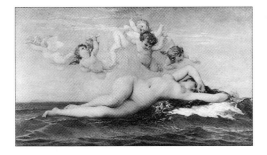

Highly acclaimed at the 1863 Salon, and purchased by Napoleon III, this painting by Cabanel (1823–89) exemplifies the sort of academic art scorned by the Impressionists. Venus lies seductively accessible on the foaming waves, cushioned by her flowing hair. From the Renaissance onwards the possibility of depicting an idealized female nude has made the birth of Venus one of the most frequently painted subjects in Classical mythology. Venus, born fully-grown from the sea and shown here sleeping beneath flying *putti*, is painted with a feminine colour scheme of pinks and blues. The fine finish of this work clearly shows how crude and sketchy the work of the Impressionists must have seemed to contemporary viewers. Manet's modern Venus *Olympia* (page 92), shown the same year as this, was vilified as crude and offensive.

MUSÉE D'ORSAY

The Poor Fisherman

1881

Pierre Puvis de Chavannes

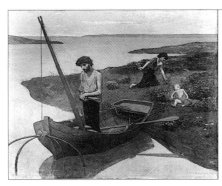

Famous for his mural paintings and large decorative works in public buildings, Puvis (1824–98) sought to reinvent traditional academic painting. His simple, spare compositions and pale chalky colour schemes are instantly recognizable and, like Gustave Moreau, whose work is displayed nearby, he exerted a powerful influence on the younger Symbolist painters who saw in his work a melancholy poetry. In this case it derives from the picturesque poverty of a Christ-like fisherman praying for a catch in a windless green lagoon. Temperamentally Puvis was attuned to the Symbolist spirit, declaring himself to be 'so miserable that the sun fatigues my sight and troubles my soul'. He confessed 'a preference for mournful aspects, low skies, solitary plains, discreet in hue, where each tuft of grass plays its small tune to the indolent breath of the wind of midday.'

MUSÉE D'ORSAY

The Angelus

1868–9

Jean-François Millet

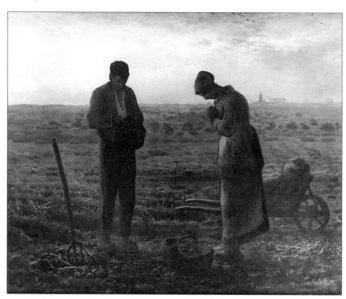

A painter of peasant life, Millet (1814–75) was born in Normandy, the son of a peasant. He moved, after training in Cherbourg and Paris, to the village of Barbizon in the forest of Fontainebleau, thirty miles outside Paris. Here Millet, along with Théodore Rousseau and Narcisse Diaz painted naturalistic rural landscapes and peasant scenes executed out of doors by natural light, thus reversing the long academic tradition of studio painting with its contrived lighting effects. *The Angelus* shows a couple breaking off from their toil in the fields and bending their heads in humble silence to pray as the Angelus bell from the distant church sounds. It is Millet's best known work and was an enormous inspiration to Van Gogh who, affected by the artist's simple and severely impoverished lifestyle as well as his subject matter, made numerous copies of this work. In the last quarter of the last century this painting became an icon of piety; copies of it were hung in every orphanage, workhouse, hospital and school as an example of faith, dignity and humility in the face of abject poverty.

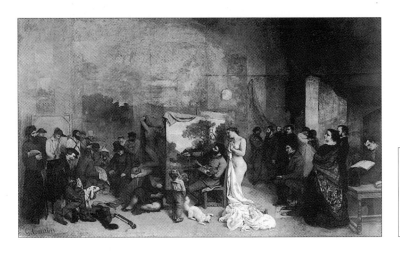

Vain and extravangantly bohemian, Courbet (1819–77) was unconventional and exciting. This giant work, subtitled 'an allegory of the last seven years of my life' celebrates Courbet the man, here personifying Genius, admired by Youth in the guise of the young boy, and Beauty, in the form of the Nude. Self-dramatizing and egotistical, Courbet presents an epic composition of the work of the artist in general, and Courbet in particular. Designed to attract response at the Universal Exhibition of 1855, this painting was rejected as was his enormous *Burial at Ornans*, set in his birthplace in the Jura mountains on the Swiss border, and also shown in this room. Courbet responded by putting up the Pavillon du Réalisme – an exhibition of forty of his own works. This setting up of an independent exhibition as a challenge to the official Salon is a precursor of later Salon des Refusés organized by Manet and the Impressionists.

Courbet's often squalid naturalism repelled and attracted in equal measure; the artist had both his detractors and his admirers. He resembles Caravaggio in terms of his wild lifestyle and in his use of friends and contemporaries to model scenes from everyday life, whose size transformed the commonplace into the dramatic. An anti-clerical socialist, Courbet was arrested after the Franco-Prussian war for assisting in the destruction of the Vendôme Column raised to Napoleon III, and he fled to Switzerland.

Olympia

1863

Edouard Manet

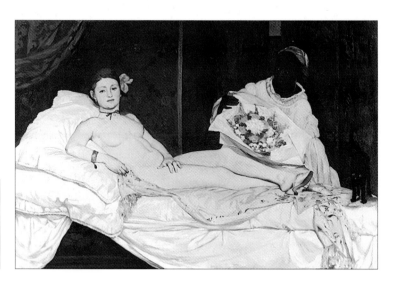

Painted the same year as Cabanel's *Birth of Venus* (page 89) this painting was vilified by almost all who saw it as an affront to public morality. A critic in *Le Grand Journal* described it as 'A sort of female gorilla, an india-rubber deformity, lying on a bed, completely nude…her hand clenched in a sort of indecent contraction. Truly, women about to become mothers, and young maidens, would do well if they were prudent to run from this spectacle'. Unlike Cabanel's nude, Manet's is clearly aware of being observed. As Zola remarked, the main objection to the painting was that 'she had the serious fault of resembling young ladies of the viewers' acquaintance.' She is clearly no classical Venus but a modern courtesan awaiting the arrival of her client who the hissing arched-back cat has already seen. Yet Manet was disappointed that his classical references passed unnoticed. His work is a modern variant on Titian's *Venus of Urbino* where the lapdog, a symbol of fidelity, has been replaced by a cat associated with cupidity. In its stark black and whiteness Manet reveals his debt to Goya whose equally controversial *Naked Maja* aroused the Spanish Inquisition.

The Symbolist poet Mallarmé put into words the painting's strange fascination. He saw in Olympia a 'wan and wasted courtesan, showing to the public for the first time the non-traditional, unconventional nude…captivating and repulsive at the same time, eccentric and new.' Decades later this painting assumed huge importance as a work which could lay claim to being the first modern painting. It has been copied and parodied by artists as varied as Gauguin, Cézanne, Picasso, Dubuffet and Larry Rivers.

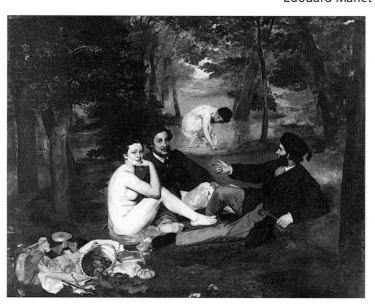

On the top level of the gallery is the world's finest collection of Impressionist paintings, and in the first room is Manet's iconoclastic shocker. When it was first shown the placing of an entirely naked woman in the company of two fully-dressed men was considered indecent. Yet as the novelist Emile Zola pointed out 'in the Louvre there are more than fifty pictures in which clothed people mix with the naked.' The principal point of antagonism was that these men were not arcadian shepherds or gods but recognizably contemporary men-about-town sitting with a woman whose modern-day clothes lie next to her and who stares brazenly and unseductively out at the viewer.

Manet (1832–83) was annoyed by the hostile criticism dished out to this work, and upset that his reinterpretation of Giorgione's *Fête Champêtre* (page 55), and Titian's *Sacred and Profane Love* (Galleria Borghese, Rome), had passed unnoticed. Manet hoped to reinvent a Classical idyll in modern form, to graft Classical and Renaissance themes on to models he saw sunning themselves on the banks on the Seine. He complained that people were unable to grasp what he wanted to show but for those brought up on a diet of academic artists such as Cabanel and Bouguereau, Manet's curious perspective, harsh coloration and elimination of half-tones must have seemed unpalatable. His friend Berthe Morisot described his work as possessing the charm of unripe fruit.

Arrangement in Black and Grey No. 1: the Artist's Mother

1871

James Abbott McNeill Whistler

The painting's full title is in keeping with many of Whistler's musical names for his works although it is more usually known simply as *Whistler's Mother*. This picture would be better displayed on the ground floor near Degas's *Bellelli Family,* since both portraits are penetrating psychological studies of relatives. Degas's group portrait reveals the tensions in his Italian aunt's family while Whistler's portrait shows a single relative in profile. Degas himself acknowledged the similarity of interest when he wrote: 'When we were beginning, Fantin, Whistler and myself, we were on the same path, the road from Holland'. By this he meant the simplicity of the black and white clothing, the dignity of pose and the inclusion of a single framed work hanging on the wall behind the sitters.

Like the Impressionists, Whistler (1834–1903) was profoundly influenced by Japanese art, especially its elimination of detail in the search for simplicity. His later works develop the Oriental theme, but in this picture only the curtains with their Japanese motif seen on the left offer a direct link with the East. The musical titles of Whistler's works, which he called compositions, arrangements, symphonies and noctures, reflect the interrelationship of music and painting that was much explored in the 1870s. Whistler conceived of his works as analagous to music, with colour playing the principal role.

Painted in Ville d'Avray where Monet (1840–1926) passed the summer of 1866, this work was planned as a major exhibition piece for the 1867 Salon, where Monet had previously only shown small paintings. A large picture with a prominent signature, it was clearly intended to draw attention to the artist and his work. It was rejected. Perhaps it was felt to be too close to Manet's scandalous *Déjeuner sur l'herbe* (page 93). The lack of narrative and the fact that this work appeared to be simply a snapshot of life did not attract critical favour. The four figures were all posed by Camille whom Monet married in 1870 and who was expecting their son Jean at the time. The subject matter – women in a sunlit garden – is pure Impressionism, but the style has more in common with the strong colour contrasts of Manet's work than with Monet's fragmented Impressionist technique of the 1870s. There is, however, a strong sense of light filtered through leaves and dappled on dresses, a feature Monet was to develop to the point of abstraction over the course of his working life. It seems hard now to imagine how the lack of dark-toned shadows and concentration on colour offended the academically-trained Salon jury of the day.

Snow at Louveciennes

1878

Alfred Sisley

Sisley (1839–99) was the great painter of snow effects. He excelled in the evocation of atmospheric conditions: snow at Louveciennes, floods at Port-Marly and early morning mists. Although not the originator of Impressionism Sisley, along with Monet and Renoir, represents its golden age. Unlike Renoir or Monet, he did not develop another style of painting but kept working within the Impressionist idiom for his entire career. Born in Paris to English parents who suffered financial ruin as a consequence of the Franco-Prussian war, Sisley stepped up his artistic output to defray his lack of parental income. He almost always chose to paint landscapes which did not feature figures in close-up, like Renoir's works. He preferred to paint indistinct figures in the middle ground in a setting whose weather conditions are almost palpable. Not one to make pronouncements, Sisley did however make an observation in a letter to the critic Tavernier: 'The sky cannot be merely a background. On the contrary, it contributes not only through the depth given by its planes...it also gives movement by its form.' This observation helps us understand how Sisley achieved his atmospheric effects. The violet-blue shadows of this snowy scene and the contrasting brushstrokes give this work a luminosity and help convey the quality of muffled silence.

Camille Pissarro

Pissarro (1830–1903) escaped working in his father's general store in the West Indies by sailing to Venezuela, after which his parents resigned themselves to his decision to become an artist. After arriving in Paris in 1855 he saw and greatly admired the work of Corot. Through his association with Courbet and Manet he developed his outdoor landscapes, living and working in desperate poverty through the late sixties. In 1870 he fled from the Franco-Prussian war to England where he stayed with his half-sister in the south London suburb of Lower Norwood.

This canvas, painted on his return to France, captures a sunlit morning in early spring; tall trees and their long shadows frame the carriage pulling out of the village. Théodore Duret in his pamphlet on the Impressionists described Pissarro as 'the most naturalistic of them all. He sees nature and simplifies it through its most permanent aspects'. When Pissarro was painting *Entry to the Village of Voisins* he and Cézanne were working closely together. The picture contains many of the elements Cézanne admired in the older man's work: it is a scene of great naturalism yet one in which the underlying tight construction and careful balance of the horizontal and vertical is clearly visible. Describing him as 'that humble, colossal Pissarro' Cézanne alluded to his patient and generous character as well as his great talent.

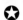

★ Ball at the Moulin de la Galette

1876

Pierre-Auguste Renoir

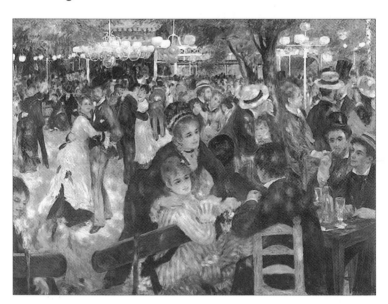

MUSÉE D'ORSAY

This is probably the artist's most famous and best loved painting. It depicts a large, shaded garden with covered dance area and bandstand next to a dance hall in a converted mill on the hill of Montmartre, which was then still a village on the edge of Paris. Renoir (1841–1919) lived there for six months, making friends with the people and sketching them in unposed attitudes. Many of his friends are represented in the painting, which contains quintessentially Impressionist themes; an interest in colour and light, outdoor painting, but more particularly delightful gatherings with music playing, couples dancing, people chatting and drinking, children playing, sun shining and everyone happy. This is a reflection of the artist's own character,which was goodnatured, fun-loving, unintellectual, warm, generous and sensuous. Renoir colours contemporary life with glamour and sheer gorgeousness, translating the working classes of Montmartre into creatures of a golden age. His light, feathery brush-strokes give a rhythmic delicacy to his work, a technique unrivalled by Pissarro or Monet. The informality of pose, and the effect of light filtered through leaves forming dappled patches of uneven colour on clothing and skin, were inimical to hostile critics who likened Renoir's skin tones to'decomposing flesh'.

MUSÉE D'ORSAY

Like Manet and Toulouse-Lautrec, Degas (1834–1917) frequently paint-
ed café scenes. Cafés were very much part of modern life and Degas was
with Baudelaire in his belief that 'the man who does not accept the con-
dition of ordinary life sells his soul.' Degas shows us café-concerts with
open-mouthed singers and short-skirted dancers, prostitutes seated round
tables and, as in this case, down-and-outs. When this painting was shown
in England in 1893 it was seen by some critics as a treatise against drink.
That it certainly was not. The weary slump of the woman staring vacantly
at her absinthe was not temperance league propaganda but a piece of
detached observation. Degas was always the observer never the participator.
The bleakness of the woman's condition is emphasized by the flat, empty
expanse of two tables at the lower left of the canvas. The composition, like
those of many Impressionist paintings, presents a snapshot, a hard-won
attempt at naturalism. Degas worked intently to create an impression of
effortlessness. The male figure here was posed by the artist's friend
Marcellin Desboutin at the Café de la Nouvelle-Athenée, to which he intro-
duced Degas, Manet and their group of friends. The actress Ellen Andrée
who frequently modelled for Degas and Renoir, is depicted here as a
demi-mondaine, either hoping to solicit or simply eking out a drink. Degas,
unlike the Impressionists with whom he exhibited, was not scorned by crit-
ics. His withering sarcasm and splenetic temper gave him a sort of pro-
tection against adverse criticism which was levelled at gentler painters like
Renoir and Monet.

Ballet Dancer Curtseying

1875

Edgar Degas

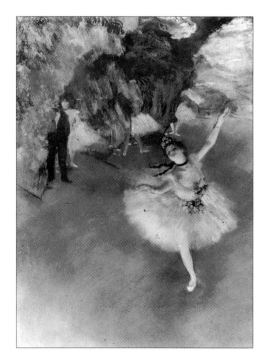

Although he exhibited on a number of occasions with Monet and his colleagues, Degas (1934–1917) was uninterested in the principal concerns of the Impressionists. Colour and light, the transience of moving things and landscape held little appeal for him. His attitude to *plein-air* painting was that all easels cluttering up the countryside should be shot down. Sophisticated and urbane, Degas's preferred subject matter was the city; the café-concert, milliners, laundresses, and ballet dancers. Like most wealthy Parisians he attended the ballet three times a week. He sketched the dancers on stage, behind the wings, at practice and at rest. He saw close parallels in the art of the dancer and that of the painter; both, he believed, endured punishing pratice to create an art which appeared effortless and spontaneous. This picture is interesting for two reasons. The first is its technique of pastel on monotype on paper. Degas invented a technique in 1874 of removing or simply drawing with printer's ink on to an etching plate, from which a single print was then taken. This monotype was then coloured with pastel crayon. Secondly, there is the unusual viewpoint. The ballerina appears to be viewed from a box at the extreme left of the theatre, yet such a position would be unlikely to reveal the wings which are clearly visible. Degas is bending realism in the interest of radical picture making, upholding his dictum that 'all art is artifice and needs to be perpetrated with the cunning of a crime'.

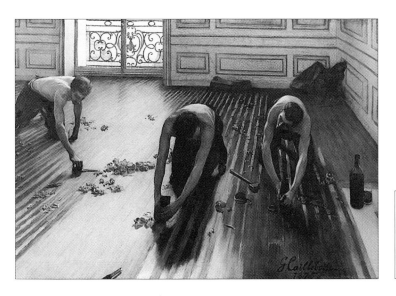

MUSÉE D'ORSAY

Caillebotte (1848–1894), an engineer and amateur painter, became a close friend of Monet whom he met in 1874 at Argenteuil, where Monet had been living since 1872. He designed a floating studio for Monet and when, in 1878, Monet was too poor and depressed to send in any paintings to the fourth Impressionist exhibition, Caillebotte collected and submitted twenty-nine of them. A friend to and collector of the Impresssionists, he helped them financially and materially. After his death in 1894 he bequeathed sixty-five works to the state including seven works by Degas, two Manets including the magnificent *Balcony*, six Renoirs including *The Moulin de la Galette* (page 98), two Cézannes, eight Monets, six Sisleys, and seven Pissarros. Twenty-nine of the bequeathed works were rejected, and even as late as 1896 were described by an academic painter as scum.

An amateur painter whose works are in no way amateurish, Caillebotte exhibited at two of the Impressionist exhibitions. There are four of his pictures in the Musée d'Orsay, and this stupendous piece of painting is as accomplished a work as any on show in the Impressionist rooms. However, it is in no way an Impressionist painting, and it has more in common with the Dutch influence seen in the work of Fantin-Latour or Degas. The everyday subject matter of workmen planing the floor of a large room beyond which a pair of distinctly French windows open out on to a shallow balcony is transformed into a vivid image of simplicity. The rhythmic movement of the young planers, the play of light on the skin of their naked torsos, and the sunlight on the wooden floor is exquisite.

The Church at Auvers

1890

Vincent van Gogh

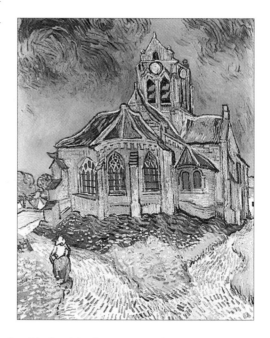

Painted two months before his death in the summer of 1890, this picture is one of the artist's masterpieces. Van Gogh (1853–90) wrote about it early in June 1890: 'I have a larger picture of the village church - an effect in which the building appears to be violet-hued against a sky of a simple deep blue colour, pure cobalt; the stained-glass windows appear as ultramarine blotches, the roof is violet and partly orange. In the foreground some green plants in bloom, and sand with the pink glow of sunshine on it. And once again it is nearly the same thing as the studies I did in Nuenen of the old tower and the cemetery, only it is probable that now the colour is more expressive, more sumptuous.'

Through his copious writings, mainly his letters to his brother, we know a great deal about Van Gogh's artistic intentions. His explanation in the letter quoted here tells us about his views on the expressive nature of colour. The use of strong, bright pigment, coupled with his dramatic brushstrokes conveys an emotional force which makes him a key figure in European Expressionism. Because he expressed his emotional state in paint and words, Van Gogh is a painter many people respond to. His art is readily accessible, the subject matter easily understood and appreciated. This, and his suicide at the age of thirty-seven, enhance the notion of him as the paradigm of the misunderstood artist whose life of poverty and madness ended in failure to be posthumously redeemed by critical acclaim.

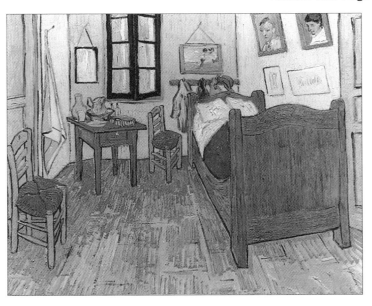

Musée d'Orsay

Van Gogh (1853–90) was following a tradition established by Dutch artists of earlier centuries in painting everyday objects and their surroundings. He drew his room in Arles on several occasions and painted it in oil three times. 'This time it's just simply my bedroom,' he wrote to his brother Theo in Paris, 'only here colour is to do everything, and giving by its simplification a grander style to things, is to be suggestive here of rest or of sleep in general. In a word, to look at the picture ought to rest the brain or rather the imagination.' His evaluation of the critical role of colour in painting is clearly evident here and was to be of supreme importance to artists like Matisse and the Fauves a decade later.

The son of a pastor, Van Gogh was a zealot with a mission to change society, initially as a minister and later as a painter. Like Millet, the artist Van Gogh most admired, he was steeped in the Bible, although he preferred to paint the piety and devotion he found in real life rather than religious subjects. After painting for a couple of years in Paris, in 1888 he went to live in Arles in the south of France, where he intended to start an artistic community. Gauguin arrived but the enterprise ended badly with Van Gogh severing his right ear after taking the razor to Gauguin's throat. At the Hospice of Saint-Paul Van Gogh painted this work based on an earlier work done the year before. It is therefore the work of a man confined to an asylum remembering his simple room at home.

Card Players

1890–5

Paul Cézanne

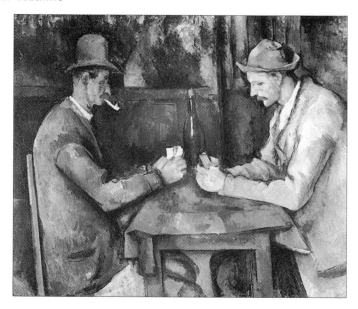

The subject matter may have come to Cézanne (1839–1906) through a Le Nain painting of the same theme which he had seen in the museum of Aix-en-Provence. Cézanne made five paintings of card players, progressively working towards a simplification of composition. The card players avoid the spectator's gaze; their focus and ours rests on the cards themselves. The composition is carefully structured: two diagonals drawn from the top to the bottom corners would intersect in the cards held by the left-hand figure.

Cézanne eschewed the great subjects of the Salon painters, preferring landscape, portraiture and genre subjects. His work might therefore be supposed to have much in common with that of the Impressionists, but there is a monumentality and insistence on form which distinguishes his pictures from theirs, as does his liking for restricted and darker tonalities, such as the browns, russets and greens of this canvas. His method of working was also painstaking and slow, rather than quick and spontaneous. Cézanne aimed to 'make of Impressionism something solid and durable, like the art of the museums.' He was obsessed with form, the underlying construction of nature and the way we see it. Famous for his quote that nature was composed of the cone, the cylinder and the sphere, Cézanne was enormously influential on Picasso and the development of Cubism, and subsequently on the development of twentieth-century art.

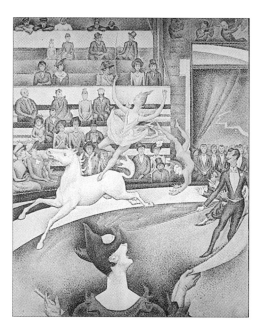

This canvas of the Cirque Fernando near the artist's studio was Seurat's last. He was described as a neo-Impressionist by a critic at the last Impressionist exhibition in 1886, where his *Une Baignade* (National Gallery, London) dominated the show. The term, with its suggestion that Impressionism had been eclipsed by a new, more interesting development, was intensely annoying to Monet and Renoir. What this critic had noted was Seurat's attempt to offer a scientific codification of Impressionist technique. The artist was interested in the science of painting and was profoundly affected by the writings of a number of scientists and colour theorists. He was an associate of Charles Henry, a mathematician who fascinated Sorbonne audiences with his lectures on the emotional value of colour and line. He claimed that pleasurable sensations were derived from warm colours, light tones and lines rising to the right, and that descending lines, cool colours and dark tones evoke sadness.

Seurat built on these theories which he developed and put into practice in his work. This painting shows not only Seurat's theories on the emotional aspect of line and colour – the upward moving lines and warm colours are meant to suggest happiness – but also his divisionist or pointillist technique: he believed in attempting to blend colour optically on the viewer's retina rather than by blending the paint itself on the painting's surface. The canvas contains a strong element of social caricature: the audience is arranged in the tiered seats according to social status, with the rich seated nearest the ring and the poor further away.

Tahitian Women

1892

Paul Gauguin

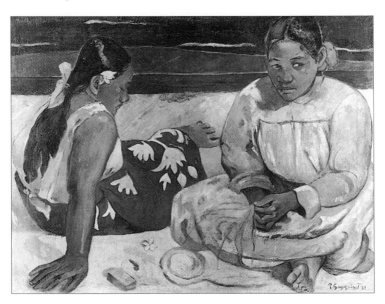

Gauguin (1848–1903) spent four of his childhood years in Peru, where the splendour and excitement of the bright city of Lima became the dream of a lost idyll on his return to the grey and rainy city of Orléans. After a period of domesticity in Paris where he became a banker, married a Danish girl and had five children, he abandoned family life for that of an artist. After exhibiting in the eighth and last Impressionist exhibition, Gauguin moved to Pont-Aven in Brittany where he found in the primitive, rural community of the north his primeval 'barbarian' soul. At Pont-Aven he was the focus of a school of artists who, under the influence of literary Symbolism, attempted to make works which created visual poetry through the use of line and colour.

In 1891 he left for Tahiti in an attempt to escape the moribund civilization of the West, and to try to discover a more primitive culture unsullied by European decadence. This work, painted in Tahiti, shows a melancholy scene of two girls on the beach. It is likely that Gauguin's thirteen-year-old mistress, Teha'amana, posed for both figures. Forms are solid and colours bright. The literary and symbolic significance of colour was of the highest importance to Gauguin, who was in no doubt about his importance in the history of painting. His main contribution to subsequent painters was, he believed, in his stress on the importance of the idea over the actual execution of the work. 'Today's painters who benefit from this new freedom' he wrote 'do owe me something.'

The Snake Charmer

1907

Henri Rousseau

An exact contemporary of the Impressionists, Henri Rousseau (1844–1910) – nicknamed 'le Douanier' because of his job on the Paris tollgates – has little in common with them. He professed admiration for the traditional Beaux-Arts trained painters like Bouguereau and Cabanel, the very artists the Impressionists despised. His retirement in 1893 gave him more time to paint, and his greatest successes came after this point. Rousseau's work is rarely that of the observed world. His art is exotic and lush, and this work is a typical example of his mature style. This jungle scene balances a dense background of tropical vegetation with an open moonlit sky beneath which lies a crudely painted river. The dark focal point is a snake charmer, whose music entrances serpents from land and water, their undulating curves suggesting a slow, rhythmic dance. Rousseau made frequent trips to the Jardin des Plantes in Paris to observe tropical plant life which he then transformed into his instantly recognizable style. Decorative and exuberant, his style possesses a modernity which prefigures much twentieth-century art, and which found its greatest admirers in this century. Artists such as Picasso and Delaunay, for whose mother this work was painted, were greatly drawn to the naive, direct quality of his work.

Jane Avril

1892

Henri de
Toulouse-Lautrec

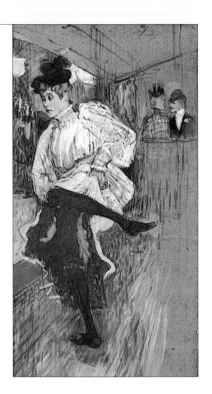

The aristocratic Henri Marie Raymond de Toulouse-Lautrec (1864–1901) was born in Albi in 1864. Stunted by a childhood accident in which both legs were broken, he became a natural outsider, a detached observer who chose to take his subjects from low-life characters of the *demi-monde*. His artistic gifts were evident from his early boyhood, and he trained in Paris and settled in Montmartre in the mid-1880s. His images are familiar to us through his posters designed to advertise cabaret artistes, clowns and can-can dancers. Jane Avril was an elegant solo dancer who performed routines that she choreographed herself at café-concerts such as the Divan Japonais and the Jardin de Paris.

The dramatic quality of Lautrec's work, in which the characteristics of Japanese prints – the use of large areas of blocked colour and dramatic viewpoints or ruthless cropping – are deployed, brought him immediate recognition. Deeply influenced by the work of Degas he depicted the same subject matter of the café-concert, the dance-hall and the brothel, vividly bringing to life the tawdry gaiety of Paris in the 1890s. Much of his work, like *Jane Avril Dancing*, is painted with thinned oil paint on hardboard using the neutral colour of the board beneath as part of the design. This work shows a contrast of finely worked face, clothing suggested by expressionist squiggles and roughly brushed in lines of colour to indicate the background. Toulouse-Lautrec's career ended at the age of thirty-seven, his health broken by alcoholism.

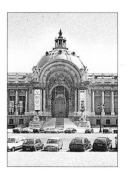

This museum is anything but *petit*. Its name is used to distinguish it from the adjacent Grand Palais; both were built for the Exhibition of 1900. The Grand Palais is a massive Art Nouveau glasshouse fronted by an astonishing stone façade. It is now an impressive venue for large temporary exhibitions, and a faculty of Paris University, while the Petit Palais houses a permanent art collection which can be viewed in a suite of rooms arranged around the garden, taking you on a pleasant semi-circular tour. The collection begins with large nineteenth-century French academic pictures like Doré's *Valley of Tears*, rooms of fifteenth-century Flemish paintings, and Italian Renaissance works including examples by Botticelli, Mantegna and Cima da Conegliano. There are also *objets d'art*, maiolica ware, ivories, and statuary. Other rooms display paintings by some of the great Dutch masters of the seventeenth century, including Hobbema, Ruisdael and Metsu. Beyond the stairway the rooms continue with a representative collection of French nineteenth-century art: there are a number of Courbets including *Sleep* and *Two Women on the Banks of the Seine*, as well as works by Corot, the Impressionists, Cézanne, Gauguin, Vuillard, and Toulouse-Lautrec. A panelled room at the end of the tour contains eighteenth-century paintings, tapestries, china and a sedan chair.

Address

1 Avenue Winston Churchill, Paris 8e

 42 65 12 73

Map reference

(23)

How to get there

Metro: Champs-Elysées, Clemenceau

Opening times

Tue–Sun 10–5.40, closed Mon.

Entrance fee

20F, 15F reduced prices. Free for under-18s and over-60s.

Two Women on the Banks of the Seine in Summer

1856–7

Gustave Courbet

One of Courbet's best known canvases, this work shows two young *demi-mondaines* lying by the water's edge on a sunny day. The writer Prudhon believed Courbet (1819–77) was presenting a moral on loose women not gainfully occupied in earning a decent wage. Proudhon saw in them creatures of animal and avaricious instinct respectively. Of the former, the brunette, he observed: 'She lies full length on the grass, pressing her burning bosom to the ground; her half-closed eyes are veiled in erotic reverie…There is something of the vampire about her. Flee, if you do not want this Circe to turn you into a beast.' Of the blonde, Proudhon had this to say: 'She too indulges in fancies, not of love but of cold ambition. She understands business, she owns shares and has money in the Funds…Quite different from her friend, she is mistress of her own heart and knows how to bridle her desires.'

It is fairly certain that Courbet did not intend a moral to be read here. He considered that he was simply recording what he saw. The critic Castagnary saw the painting's original title *Two Women of Fashion under the Second Empire* as an impertinence, the implication being that the era was one of decadence and immorality. It is interesting to note that in all the press comment of the day, no mention of the ladies' state of undress occurs. It is quite clear that the figure in the foreground is lying in her chemise, corset and petticoat, on her dress. Eroticism under the guise of mythology was acceptable, in modern dress it was not.

Maurice Denis

The title of this work perfectly evokes the mystic symbolism of Maurice Denis (1870–1943), bringing together many interrelated strands of Symbolism and Catholicism. It is a sketch for the a work made for Moreau-Nelaton now in the Musée des Arts Décoratifs. A profoundly erudite man, Denis produced clear, bright, decorative works which present the modern world in an idealized, glowing landscape. The word 'sacred' connotes religious themes but Denis's symbolism is not interpretable through recognizable symbols but through colour and the shapes which contain these colours. Denis famously remarked that 'a picture, before being a horse, a nude or some kind of anecdote, is essentially a flat surface covered with colours assembled in a certain order', a remark which was to have tremendous impact on the theory of abstract art of the twentieth century.

In 1889 Denis became a founder member of a group of painters called the Nabis, a name deriving from the Hebrew word for prophets. The group included Paul Sérusier, Pierre Bonnard, Edouard Vuillard and Félix Vallotton, who formed an independent group within the wider Symbolist movement. The founding of this group was inspired by a small, bright picture painted by Sérusier under Gauguin's instructions, and shown to the other students at the Académie Julian who were profoundly impressed. Gauguin remained the chief influence on the Nabis, whose doctrine Denis summed up as one based on a purely decorative concept. The Nabis were also decorative and applied artists, and were a formative influence on Art Nouveau.

Portrait of Ambrose Vollard

1899

Paul Cézanne

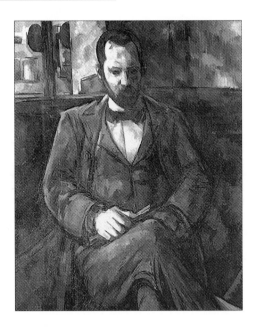

Ambrose Vollard was one the greatest art dealers and publishers of the early modern age. Abandoning his legal studies in Paris to become a full-time art collector and dealer, he bought major paintings from Manet, Renoir and Cézanne, as well as the only painting Van Gogh ever sold. Towards 1893 he opened a small gallery of his own in the rue Lafitte. It remained here until World War One and was the centre for avant-garde art in Paris, providing a meeting place for artists and collectors. He was a friend of Cézanne (1839–1906) whose first exhibition he organized, and who painted him in 1899.

Cézanne was an extremely slow worker and required at least a hundred sittings for this portrait. During these interminable sessions Vollard was advised by Cézanne to be like an apple – absolutely immobile. To prevent Vollard from falling asleep or shifting slightly, the artist perched his chair on a precariously balanced pile of boxes or tables which would topple at the slightest movement. Vollard did nod off and fell with a crash to the floor, ending the sitting of that particular day. Vollard asked Cézanne why two spots of unpainted canvas remained on the knuckles of the right hand, to which the painter replied that he had to think very carefully before covering them up, because if the tones were incorrect he would have to start again. This fastidiousness is extraordinary, but shows how Cézanne worked, building up volume through precise tonal relationships between one colour and the next. The entire image depends on the most rigorous balance of meticulously researched strokes which the slightest imbalance would destroy.

Here in the former Hôtel Salé, which takes its name from the collector of the hated salt tax who was its original occupant, is the Picasso Museum. The collection is based on Picasso's own, as well as works donated to the museum in lieu of inheritance taxes. Inside this beautifully restored seventeenth-century building Picasso's long and prolific life is documented with relevant works from the early Blue Period, through Cubist and the later Neoclassical canvases right up to his mature works. The painting collection has few of Picasso's great works, for the French state did not make the type of inspired purchases made by Swiss, American and Soviet avant-garde collectors, but it does enable an appreciation of the variety of techniques used by the artist. As well as paintings in mixed media there are plates, vases, ceramic owls, assemblages, collages, reliefs, drawings and etchings.

The sculpture collection is matchless, and contains everything of note made by Picasso including *The Goat*, *Girl Skipping* and the *Bull's Head* – a cast bronze piece combining a bicycle saddle beneath a handle bar. Of particular interest is Picasso's own art collection which includes primitive Nimba masks from New Guinea, Grebo masks, Iberian bronzes, sketches by Giorgio de Chirico and Degas, and paintings by Corot, Cézanne, Chardin, Renoir, Matisse, and others.

MUSÉE PICASSO

Address
Hôtel de Salé, 5 rue de Thorigny, Paris 3e
✆ 42 71 25 21

Map reference

㉔

How to get there
Metro: Chemin-Vert, St-Paul, St-Sebastian
Buses: 29, 96, 75, 86, 87
RER: Châtelet-les-Halles

Opening times
Wed to Mon 9.15–6. Closed Tue.

Entrance fee
28F, 18F under 18s.

Self Portrait with a Blue Background

1901

Pablo Picasso

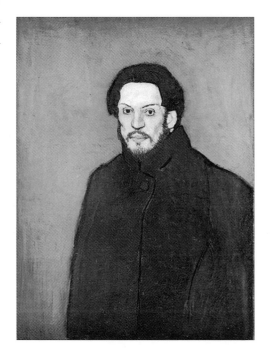

Picasso (1881–1973)is the great giant of the twentieth century. His creative force was expressed in all forms of the plastic arts from painting and sculpture through to the decorative arts. In 1900 Picasso was living in Paris where he shared a studio with his friend, the painter Casagemas. In February the following year Casagemas committed suicide: this launched Picasso into his Blue Period. 'For the space of a year', wrote Apollinaire, 'Picasso's existence was immersed in this wetness of paint, blue as the damp bottom of the abyss, and pitiful.' Works painted between 1901 and 1904 are often sentimental and literary, portraying emaciated woeful faces, before the arrival of the lighter palette of the Rose Period.

The spirit and style of Picasso's Blue Period is represented by this particular painting. This stark portrait made at the end of the year shows a face staring bleakly out at the viewer. Highly suggestive of a portrait by Van Gogh in its expressive intensity and simplification of colour and style, this work is stripped of all detail in the clothing and background which is simply blue, a colour which contained for those in Picasso's circle literary associations of sorrow.

1922

Pablo Picasso

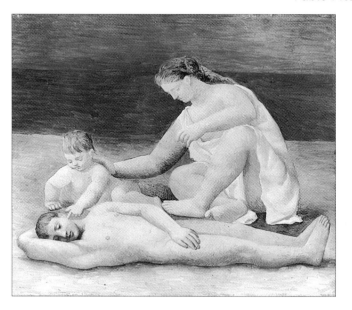

Painted in 1922 this canvas was made in Picasso's so-called Neoclassical period when he returned to a more naturalistic style after his primitive and Cubist works of 1906–16. In 1917 Picasso (1881–1973) went to Italy with Cocteau to work with Diaghilev's ballet company. In Rome, designing for the ballet *Parade* with Satie, Cocteau and Diaghilev, Picasso met his future wife, Olga Kokhlov, a Russian dancer and member of the ballet company. In 1921 Olga gave birth to a son, Paulo, and this in turn led to scenes of family and fatherhood, and to the pictures of young Paulo as Harlequin and Pierrot which can be seen in this collection. Seaside visits to Biarritz and later to the Côte d'Azur led to paintings of sunbathers, water and bodies on the beach, where his style became more Mediterranean and his themes more Classical. Cocteau, at the same time, was using Classical themes in his plays. This rather stylized painting combines the tender and the comic in the depiction of a loosely draped woman gently restraining her naked son as he pokes a finger against the neck of his sleeping father.

Address

77 rue de Varenne, Paris 7e

✆ 47 05 01 34

Map reference

㉕

How to get there

Metro: Varenne

RER: Invalides

Opening times

Tue to Sun 10–5.45

(4.45 in winter). Closed

Mon.

Entrance fee

20F, 10F reductions.

The Rodin Museum is housed in the former Hôtel Biron, one of the finest eighteenth-century mansions in Paris. The original woodwork is preserved in many of the rooms, and the large windows and doors fill the rooms with light and offer vistas of the surrounding garden. The Hôtel had been state owned since 1901 and was rented by Rodin (1840–1917) from 1908 until his death. The two rooms on the ground floor were used as a studio, and the rooms above were his lodgings. Between 1908 and 1909 they were also those of the poet Rilke who was, for a period, Rodin's secretary.

By 1908 Auguste Rodin was sixty-eight years old and held in the highest esteem, as the presentation of the Légion d'Honneur in 1910 testifies. In 1916 he suffered a stroke and bequeathed his work to the nation on the condition it remained in the Hôtel Biron. The museum contains the world's greatest collection of Rodin's sculpture and drawings, and they are beautifully laid out. Highlights of the ground floor display are *St. John the Baptist, The Kiss, The Hand of God, Iris, The Age of Bronze, Orpheus* and *Eve*. On the first floor are models for the *Gates of Hell*, busts of *Hugo*, nude studies of *Balzac, Man with a Broken Nose* and *Eternal Spring*. There are also paintings by Renoir, Monet and Van Gogh. In the garden there are a number of works in bronze and marble including *The Burghers of Calais, The Thinker, Hugo at Guernsey,* and *The Gates of Hell*

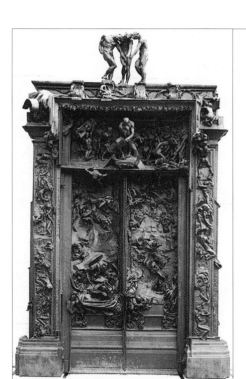

These gates originated with a government commission in 1880 to design a sculptural portal for the new Museum of Decorative Arts. Initially Rodin selected the theme of Dante's *Inferno* as his inspiration. He wrote: 'I lived a whole year with Dante, drawing the eight circles of his Hell. At the end of the year…I began all over again…working with models. I abandoned my drawings from Dante.' The Dantesque themes are visible in several of the sculptures: the Three Shades at the top of the portal, Dante himself perhaps as the Thinker, Paolo and Francesca and Ugolino and his Sons in the lower left door panel. Those falling or sinking also call to mind Dante's Hell. Onto this theme Rodin grafted figures from the Christian world, which of course are the substance of much of Dante's work, and Classical mythology. *The Gates of Hell* are, wrote the critic and journalist Gustave Geoffroy 'the assemblage in animated movement of the instincts, the fatalities, the desires, the despair of all that cries out and moans in man…a collection of all the non-changing aspects of humanity of all the countries and all periods.' In other words Rodin was expressing a timeless vision of the tragic destiny of man. James Huneker was later to see in these gates 'a frieze of Paris as deeply significant of modern inspiration and sorrow as the Parthenon frieze is the symbol of the great clean beauty of Hellas.'

The Kiss

1898

Auguste Rodin

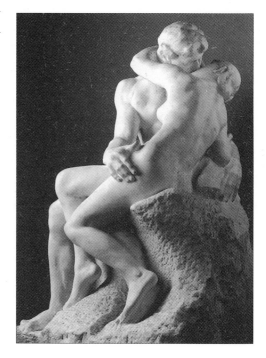

Although Rodin (1840–1917) was to describe his statue of the great writer Balzac as 'the result of my entire life, the very pivot of my aesthetic' it was *The Kiss* not *Balzac* that he chose as the centrepiece of his work at the Salon of 1898. This decision was probably made to offset unfavourable reaction to *Balzac*, for *The Kiss* is a work designed to appeal to conservative taste. Unlike *Balzac* this work shows Rodin working in a traditional manner, turning marble into flesh and blood, muscle and bone. Antoine Bourdelle who assisted Rodin said of the master, 'There has never been, there will never be a master able to impress upon the clay, upon bronze, upon marble the forms of tangible things with more profundity and intensity than Rodin.' Rodin's most important contribution to modern sculpture was to breathe life into a style grown moribund under academic training. Like Michelangelo, he imagined that his divine gift was in unleashing the figure imprisoned in the marble. In an essay of 1889 Gustave Geoffroy hailed him as a new Michelangelo who would restore the strong passions which two centuries of polite art had banished.

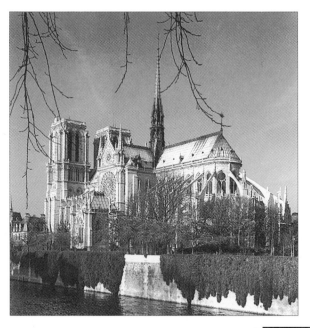

NOTRE-DAME

The world owes an immense debt of gratitude to Eugène Viollet-le-Duc, whose restoration work in the nineteenth century saved this great Cathedral. Although Notre-Dame is now regarded as one of the key defining examples of the style which was to become known as Ile-de-France Gothic, by the early nineteenth century few Parisians valued their medieval past very highly. Interest in the building was largely rekindled by Victor Hugo's novel *Notre-Dame de Paris*. Viollet-le-Duc worked for twenty years at Notre-Dame, adding the spire, consolidating the fabric and replacing missing or defaced sculptures. Work began on the Cathedral in the twelfth century, and was mainly completed by 1302. Changes in architectural taste have not served Notre-Dame well. In the eighteenth century, much of the medieval glass was removed simply to make the building lighter, and medieval fittings and furniture were often replaced by those in later styles. The building and its sculptures suffered from vandalism during the Revolution and for a brief period the Cathedral was renamed The Temple of Reason.

Address
Place du Parvis de Notre-Dame, Paris 4e
© 43 29 50 40

Map reference
㉖

How to get there
Metro: Cité

Opening times
Jan to Sept daily 9.30–6.30.
Oct-Dec daily 9.30–5.30.
Closed Sunday.

Entrance fee
Tower: 31F adults, 20F reductions.
Crypt: 27F adults, 7F reductions.

Tours
Tours of crypt and tower

THE PANTHÉON

Built 1755–89

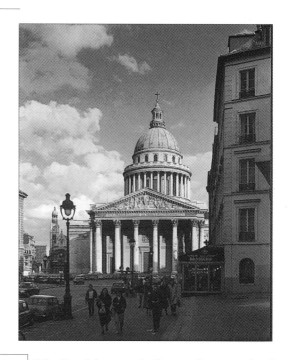

Address
Place du Panthéon, Paris 5e
© 43 54 34 51

Map reference
㉗

How to get there
Metro: Cardinal Lemoine
Bus: 21, 27, 38, 84, 85, 89
RER: Luxembourg

Opening times
April to Sep 9.30–6.30.
Oct to March 10–6.30.
Last admission 5.45.

Entrance fee
Entrance to crypt 26F

Tours
Guided tours in summer

The Panthéon was built as a direct result of Louis XV's illness at Metz in 1744. He vowed that should he recover he would give an offering of thanks by building a magnificent structure to replace the half-ruined church of the abbey of St. Genevieve. Due to lack of funds building work did not begin until 1755. The architect Soufflot designed a building based on the nobility of Classical prototypes: a dome surmounts a Latin cross plan which is fronted by a Greek temple façade. Soufflet died in 1780, and the church was completed in 1789. Two years later the ruling assembley closed the building. No longer was it to be the church of St. Genevieve, but a vast mausoleum to 'receive the bodies of great men who died in the period of French liberty'. The windows were blocked, thus enforcing the solemnity of the interior. The building alternated between being a church and mausoleum throughout the last century. After the collapse of stone work in the vaults in 1985 it has had to be closed for an indefinite period, although the crypt can still be visited. Here lie the mortal remains of France's honoured dead including Mirabeau, Voltaire, Rousseau, Hugo and Zola.

Laid out 1804

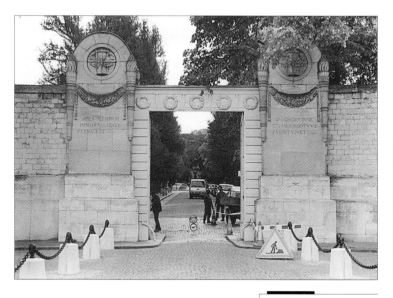

The cemetery was named after Louis XIV's Jesuit confessor, who owned the wooded hillside to the east of the city; it was later bought by the Prefect of Paris in 1803 under Napoleon's direction. Created on rolling hills following designs by Brogniart in 1804, the cemetery was increased six-fold during the last century, and the 100,000 sepulchres now receive a million visitors a year. Here among the wooded avenues lined with impressive funerary monuments are the graves of the famous dead. They include celebrated foreigners who came to Paris to die: Oscar Wilde, whose monumental tomb was designed by Jacob Epstein; the Polish composer Frederick Chopin; and rock musician Jim Morrison, who has today's cult celebrity following. From the stage world are Sarah Bernhardt, Yves Montand and Simone Signoret. The literary dead include Balzac, Proust and Apollinaire, and among the artists are David, Géricault (with the *Raft of the Medusa* on the side of his tomb), Delacroix, Corot and Modigliani. Colette is here along with Gertrude Stein and Alice B Toklas, and Edith Piaf unrecognizable under her married name of Mme. Lamboukas.

Address

16 rue du Repos, Paris 20e

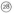 43 70 70 33

Map reference

㉘

How to get there

Metro: Père Lachaise,
Philippe Auguste

Bus: 61, 69, 26

Opening times

Daily 8–7.

Entrance fee

No admission charge.

Built 1875–1914

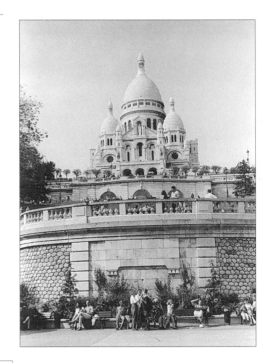

Address

35 rue du Chevalier de la
Barre, Paris 18e

✆ 42 51 17 02

Map reference

How to get there

Metro: Abbesses (then take
funiculaire) Anvers, Barbès-
Rochechouart,
Château-Rouge, Lamarck-
Caulaincourt.

Bus: 30, 54, 80, 85

Opening times

Basilica 7am-10.30 pm

Entrance fee

Free to basilica.
Dome: 15F (5F for groups);
Crypt: 10F (8F for groups).

The basilica of the Sacred Heart dominates
Montmartre. It was built as a pious response to
the Franco-Prussian war and the Paris
Commune. A mixture of Byzantine and
Romanesque styles, it was designed by Paul
Abadie, who had earlier restored St. Front at
Périgueux, which was to prove a source of inspi-
ration for this edifice. The building's extraordi-
nary whiteness is a result of the material used in
its construction: Château-Landon stone bleach-
es with age. The basilica is built on a vast scale
to take full advantage of its commanding site.
The façade is impressive: the triple-arched por-
tico is surmounted by two bronze equestrian
statues of St. Joan of Arc and St .Louis by H.
Lefèbvre, and the climax of the overall design is
the statue of Christ, his hand raised in blessing.
The interior is extensively decorated with
mosaics: those in the apse over the high altar
were designed by Luc-Olivier Merson and show
Christ adored by the Virgin, St. Joan of Arc and
St. Louis.

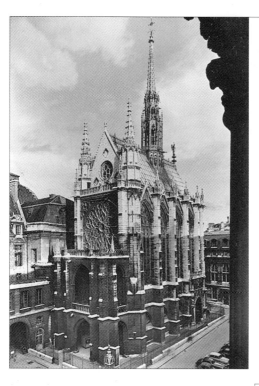

Sainte-Chapelle is one of the most heartrendingly beautiful buildings in the world – one which no visitor to Paris should miss. It has become a truism to describe the interior of the upper section as a jewel box, but no other term seems as evocative of the brilliant, saturated colours of the stained glass and the exquisite perfection of its Gothic architecture. The chapel was built to house Louis IX's collection of relics, including the Crown of Thorns which he had acquired in 1239 from the Emperor of Constantinople. The cost of the relics exceeded that of the chapel itself, which was built by the architect Pierre de Montreuil in 1248. The upper chapel, which is reached from a staircase in the lower chapel, is Gothic architecture at its most daring and successful: an airy cage of light whose slender columns seem to extend effortlessly towards the vault. The glass is amongst the oldest in Paris and dates from the thirteenth century: many biblical narratives from the Old and New Testaments can be identified. The relics are now housed in the Treasury at Notre-Dame.

Address
Boulevard du Palais, 1e
© 43 54 30 09

Map reference

How to get there
Metro: Cité, Chatelet

Opening times
April to Sept 9.30–6.30.
Oct to March 10–4.30.

Built 1661-1710

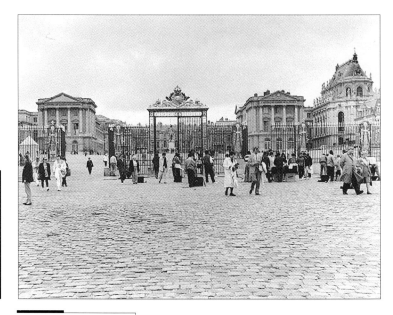

Address

Château de Versailles, Versailles

✆ 30 84 74 00

Map reference

How to get there

RER: Versailles Chantiers, Versailles Rive Gauche

Bus: 171

Opening times

Oct to April 9–5.30 daily. May to Sept 9–6.30. Grand and Petit Trianon: Tue to Fri 10–12.30, 2–5.30. Sat and Sun in winter 10–5.30 . Daily in summer 10–5.

Entrance fee

40F, 26F for 18–25s and over 60s. Sun 26F. Under 18 free.

The real creator of the château of Versailles was the Sun King Louis XIV, who sought to erect a glorious monument to his reign. Louis Le Vau was commissioned to renovate and extend an old hunting lodge, Le Nôtre created the gardens from swamp land, and Mansart masterminded the hydraulic display of the fountains. The size of the workforce was formidable, and the expense of materials impoverished the country, which became centred on the court at Versailles. It must be remembered on a visit here that the wings of the building would have been subdivided into numerous apartments housing courtiers and their families. By 1790, the year after the Revolution, it was almost bare. Only a small part of the palace can be visited: the State Apartments of the King and Queen, and the Hall of Mirrors. It is best not to visit on a Sunday when the entrance fee is reduced but queues are interminable. A guided tour for an extra twenty-four francs takes in the King's Private Bedroom, the Royal Opera, and the rooms occupied by Madame du Barry. Extra is also charged to see the pavilions of the Grand and Petit Trianons.

The author and publishers would like to thank the following individuals, museums, galleries and photographic archives for their kind permission to reproduce the following illustrations:

A.F.Kersting: 6, 16, 18, 51, 119, 120, 123

Musée du Louvre (photo Bridgeman Art Library): 7a&c, 9a&b

Musée du Louvre (© photo R.M.N.): 7b, 8, 9c, 10b, 52a&b, 53, 54, 55, 56, 57, 58, 59, 60, 61, 62, 63, 64, 65, 66, 67, 68, 69, 70, 71, 72, 73a&b, 74, 75, 76, 77, 78.

Château de Versailles (© photo R.M.N.): 10b

Raquel Dias: 11, 19, 28, 29, 30, 31, 32, 33, 39, 41, 43, 45, 46, 47, 48, 49, 50, 79, 82, 84, 85, 87, 109, 113, 116, 121, 122, 124.

Musée Marmottan (photo Bridgeman Art Library): 12.

Musée Marmottan: 80, 81.

Musée d'Orsay (© photo R.M.N.): 13a&b, 88, 89a&b, 90, 91, 92, 93, 94, 95, 96, 97, 98, 99, 100, 101, 102, 103, 104, 105, 106, 107, 108.

Centre Georges Pompidou (photo © Musée National d'Art Moderne): 20 (© Succession H.Matisse/DACS 1995), 21(© DACS 1995), 22(© ADAGP, Paris and DACS, London 1995), 23(© ADAGP, Paris and DACS, London 1995), 24(© DACS 1995), 25(© DACS 1995), 26(© ADAGP, Paris and DACS, London 1995), 27(© DEMART PRO ARTE/BV, DACS 1995).

Musée d'Art Moderne de la Ville de Paris: 35(© Succession H.Matisse/DACS 1995), 36(©ADAGP,Paris and DACS,London 1995), 37(© DACS 1995), 38(© ADAGP/SPADEM, Paris and DACS, London 1995).

Musée Carnavalet: 40.

Musée de Cluny (© photo R.M.N.): 42.

Musée Cognacq-Jay: 44.

Musée Gustave Moreau (© photo R.M.N.): 83.

Musée de l'Orangerie (© photo R.M.N.): 85.

Agence Photographique de la Reunion des Musées Nationaux (© photo R.M.N.): 88.

Musee du Petit Palais: 110, 111.

Musee du Petit Palais (photo Bridgeman Art Library/Giraudon): 112.

Musée Picasso (© photo R.M.N.): 114(© DACS 1995), 115 (© DACS 1995).

Musée Rodin (Adam Rzepka photo © ADAGP, Paris and DACS, London 1995): 117.

Musée Rodin (Bruno Jarret photo © ADAGP, Paris and DACS, London 1995): 118&b

Photothèque des Musées de la Ville de Paris © DACS 1995: 35, 36, 37, 38, 40, 44, 111

The author would also like to thank Sharon Cutler and Hilary Guise for their assistance.

INDEX

Index of Artists, Sculptors and Architects
Figures in bold refer to main entries

A note on the itineraries

The following itineraries are designed for those with a week in Paris, and for practical reasons museums or buildings that are near each other have been grouped together on the same day. It is worth bearing in mind that most of the city's museums close on Mondays or Tuesdays and the Musée du Louvre, Pompidou Centre and Musée d'Orsay have late opening hours on certain days. Although it should be possible to view all the items suggested on each day's itinerary, visitors may well choose to proceed at a more leisurely pace and concentrate on one or two of the suggested items while excluding others. Those with limited time should focus on the starred items. Works of art are listed in the order that they are most likely to be seen within each museum or gallery. The numbers in circles beside each location are map references.

For those planning an intense spate of gallery visiting, the Carte Inter-Musées is essential. It is available from metro stations or the galleries themselves, and can be bought at a daily, three-day or weekly rate. The entry fees and opening times for museums and buildings are correct at the time of publication, although they may be liable to change without prior notice.

DAY 1 MORNING

✪ **MUSÉE DU LOUVRE** ⑰ (p.50)
Closed Tuesday

✪ **Venus de Milo** (p.52)
Winged Victory of Samothrace (p.52)
Madonna and Child with Angels
Sandro Botticelli (p.53)

✪ **Marriage at Cana**
Paolo Veronese (p 54)
Fête Champêtre
Giorgione and Titian (p.55)

✪ **Mona Lisa**
Leonardo da Vinci (p.56)
La Belle Ferronière
Leonardo da Vinci (p.57)

✪ **The Raft of the Medusa**
Theodore Géricault (p.58)
Madame Récamier
Jacques-Louis David (p.59)
Liberty Leading the People
Eugène Delacroix (p.60)
The History of Marie de Medicis
Sir Peter Paul Rubens (p.61)
Gabrielle d'Estrées and her Sister
School of Fontainbleau (p.62)
Eva Prima Pandora
Jean Cousin the Elder (p.63)

✪ **Madonna of the Chancellor Rolin**
Jan van Eyck (p.64)
Jehan Braque Triptych
Rogier van der Weyden (p.65)

The Ship of Fools
Hieronymus Bosch (p.66)
Self Portrait with a Thistle
Albrecht Dürer (p.67)
Erasmus
Hans Holbein the Younger (p.68)
The Lacemaker
Jan Vermeer (p.69)
Bathsheba in her Bath
Rembrandt van Rijn (p.70)
The Cheat
Georges de la Tour (p.71)
Ex Voto
Philippe de Champaigne (p.72)
Et in Arcadia Ego
Nicolas Poussin (p.73)
The Embarkation of Cleopatra for Tarsus
Claude Lorrain (p.73)

✪ **Gilles**
Jean-Antoine Watteau (p 74)
The Bolt
Jean-Honoré Fragonard (p.75)
Young Draughtsman Sharpening his Pencil
Jean-Baptiste-Siméon Chardin (p.76)
Grande Odalisque
Jean-Auguste-Dominique Ingres (p.77)
Souvenir de Mortefontaine
Jean-Baptiste Camille Corot (p.78)